THE SCIENCE FICTION ART OF
VINCENT DI FATE

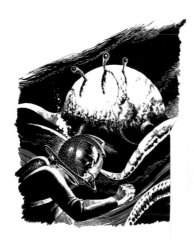

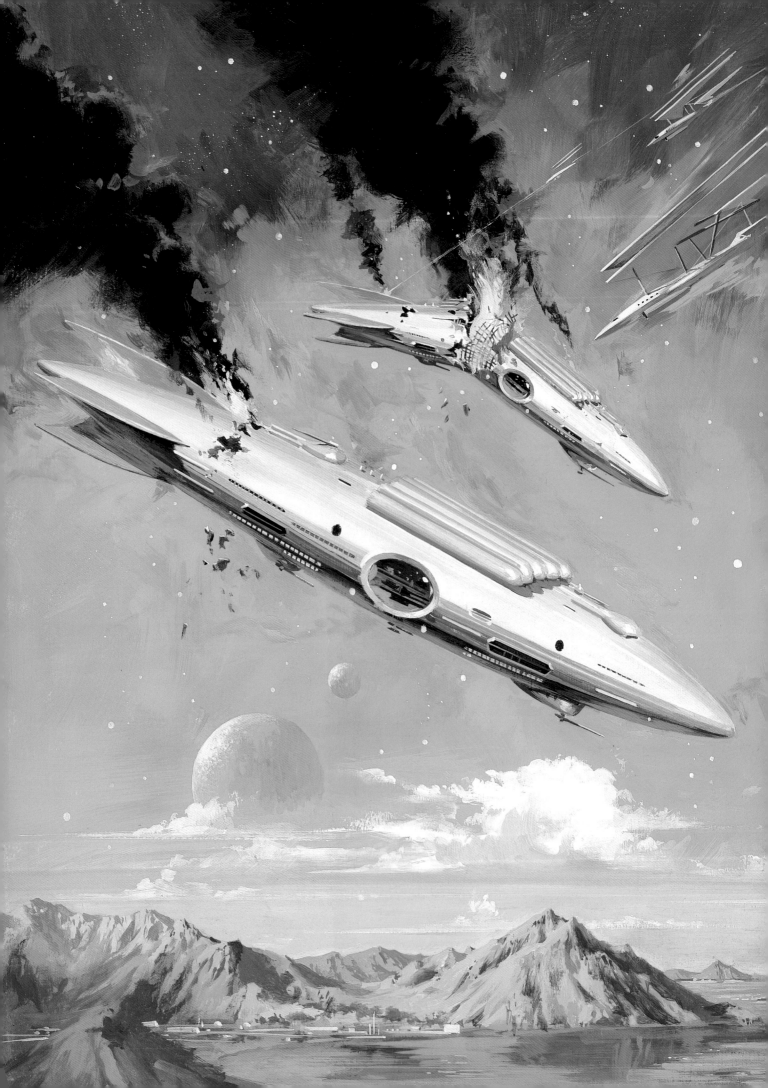

THE SCIENCE FICTION ART OF
VINCENT DI FATE

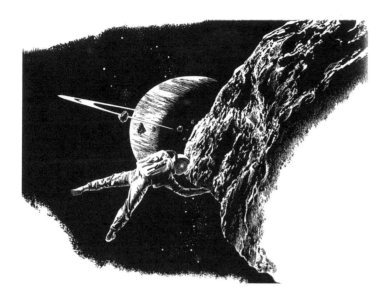

The Pandora Probe

Analog, 1994
Pen & ink on scratchboard
Approx. 10in x 6in (25cm x 15cm)

When I first read Jerry Oltion's story 'The Pandora Probe',
I knew that its author was destined to become a genre star.
There are so few good hard-sf writers these days that it seemed
inevitable to me. The story had everything: action, adventure,
atmosphere, mystery and an exotic location. It ran in the
December 1994 issue of *Analog.*

PRECEDING PAGES
Hatching the Phoenix

Amazing Stories, 2000
Acrylics on hardboard
22in x 15.375in (56cm x 39cm)

Back in the mid-1970s I'd been fortunate enough to illustrate
one of the greatest sf novels ever written for its serialization in
Galaxy. The novel, *Gateway* by Frederik Pohl, went on to win
both the Nebula and Hugo awards for Best SF Novel, and just
about every other major accolade in the field that year (1977).
It told a riveting tale of the Heechee, an ancient race that had
colonized the Solar System long before the time of Man and had
left behind their mysterious, pre-programmed ships at Gateway,
a space station in orbit near Mercury. The book spawned several
sequels; 'Hatching the Phoenix', a novella, is the most recent
instalment. The novella ran in two consecutive issues of *Amazing
Stories,* and it was pure heaven to step back into the realm of the
enigmatic Heechee and the magnificent machinations of one of
sf's most brilliant sagas.

FACING PAGE
Time Travelers Strictly Cash

Ace, 1980
Acrylics on hardboard
Approx. 14in x 20in (36cm x 51cm)

In the 1970s Spider Robinson wrote a series of charming short
stories set in a friendly bar called Callahan's Place. Callahan was
no ordinary barkeep, his place was no run-of-the-mill saloon,
and his patrons were far from common – to the Earth, that is.
The stories were far more subtle in their sf content than this
painting would suggest, but, in the wake of the famous cantina
scene in the movie *Star Wars* (1977), the art director felt there
was little room to be coy.

First published in Great Britain in 2002 by

Paper Tiger

64 Brewery Road

London N7 9NT

A member of the Chrysalis Group plc

Distributed in the United States and Canada by

Sterling Publishing Co.,

387 Park Avenue South, New York,

NY 10016, USA

1 3 5 7 9 8 6 4 2

British Library Cataloguing-in-Publication Data:

A catalogue record for this book is available from the

British Library

ISBN: 1-85585-949-1

Commissioning Editor: Paul Barnett

Designer: Malcolm Couch

Colour reproduction by: Global Colour, Malaysia

Printed by: Craft Print International Ltd

CONTENTS

INTRODUCTION

FOR SOMETHING OVER THREE DECADES now I've consistently produced between eighty and a hundred illustrations a year. They have been, without a single exception, pictures about science, science fiction, fantasy and supernatural horror.

To state my case as honestly and as directly as I can, I'm simply incapable of doing anything else. It may surprise some of you to learn that, even while restricting myself to the subjects I like, I still find the work extremely difficult and at times torturous. I have no interest in painting for myself and no secret wish for greater artistic achievement. I derive no more enjoyment from painting than I would from going to the dentist or in doing a dozen other things that I find less than pleasurable. I am an illustrator, plain and simple. My job is to create artwork to order and to do so on deadline. In all those years I have never failed to do at least that. To do these things consistently requires a great deal of diligence, creativity and skill. I may indeed be lacking in these attributes, but apparently no one has noticed.

For me my years as an illustrator have been a disheartening exercise in coming head-to-head with my inability to attain the beauty of what I see in my mind's eye. While I like the process, I've never been completely comfortable with the product. It is only after the passage of many years that I can look back at what I've done and take comfort in the belief that my efforts might not have been as poor as I imagined. Some of the images you are about to see are still too new for the separation and healing process to have run its course. They are like seething wounds in the flesh, erupting in pain and swollen with infection, begging for urgent treatment.

Do I strike you as a tortured soul? Have I made it all sound unsavoury enough for you? If I have, then you still don't know the half of it. If you know me – I mean *really* know me – then you know that I'm not a tortured soul . . . at least, not outwardly. I lead a happy, normal and

productive life in every way – except one. My 'art' (if one can call it that) is my cross to bear.

Over the years I've been asked to do books like this before. I have resisted until now because of the reasons I've just stated. But, in thinking about and ultimately assembling the components of this book, I've come to an important revelation: this book isn't really about me, it's about something much greater – it's about science fiction. It's about possible futures, about other lands and other beings who have much to teach us about who we are, for in seeking those lands and meeting those beings we must confront our own humanity.

Long before I ever picked up a pen or a brush, there was this incredible literature in my life. It provided me with escape and comfort; it gave me strength in the knowledge that tomorrow was a new day with new challenges, but also with the prospect that it might be a better day than today or the day before. What greater comfort has life to offer than the thought of what *could be*?

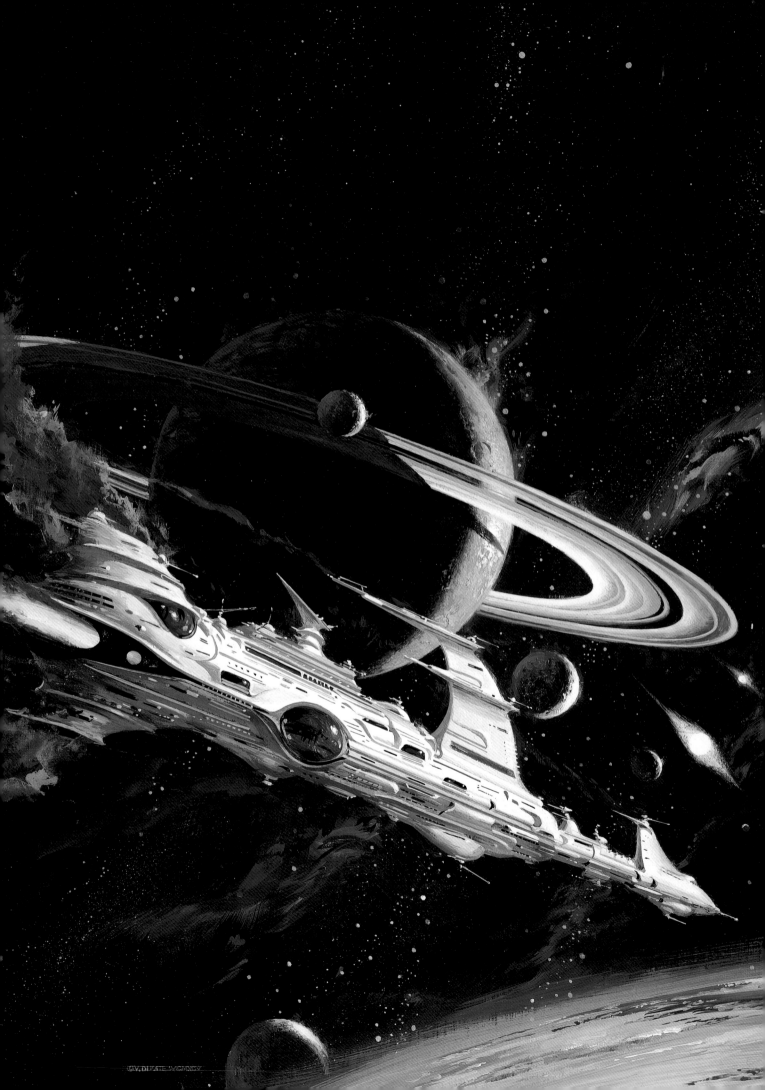

THE INFINITE IN BLACK AND WHITE (AND SHADES OF GREY)

WHEN I'M ASKED, I usually say that my career began in 1969. But that's not completely true. I actually started working as an illustrator when I was 19 and still in art school. The magazines *Galaxy* and *Worlds of If* were published out of a warehouse on Houston Street in New York City at the time, and were located just a few miles from the school I was attending. I'd placed a call to Judy-Lynn Benjamin, then the editorial assistant for the magazines, and on a February afternoon in 1965 I walked the thirty blocks through the snow and slush to Houston Street to show her my portfolio. I walked out of Ms Benjamin's office a short time later with two manuscripts under my arm and with mixed feelings of excitement and trepidation. Those first few drawings were sheer torture for me, and I redid them several times before submitting them. Although they were accepted and paid for, I'm not entirely certain they were ever used.

Thus it would fall to John W. Campbell, some five years later, to give me my 'official' start. Judy-Lynn (who would later become Mrs Lester del Rey) and I eventually got to work together in the late 1970s when she became the editor of Ballantine's newly initiated sf imprint, Del Rey Books. I think I did some of my very best paperback work for her – some examples are included in this book.

Over the years, much has been written about John Wood Campbell Jr and his influence on the literature of science fiction. Campbell, as the editor of *Astounding Science Fiction* (later renamed *Analog*) and the short-lived but much beloved fantasy magazine *Unknown*, was a formative presence in the field, and is thought by some to have been the most significant force in the development of modern science fiction. True or not, saint or devil, John W. Campbell was the first person to take my art seriously and to provide me with work on a regular basis. To me, an avid sf reader in my early twenties having virtually no contact with the genre aside from the books and magazines that I read so rapaciously, he seemed larger than life. Tall and baleful in appearance and austere in manner, he was more than merely the first sf celebrity that I had encountered – he was, to my impressionable young mind, more like a Homeric god. He had, after all, written one of the most widely celebrated novellas in the genre, the classic 'Who Goes There?', and he was both revered and, to a lesser degree, vilified for his editorial authority. I learned from his example that in the 'popular' arts it is better to be loved, or even hated, than it is to be ignored.

Campbell began his involvement in sf as a writer in the early 1930s, and by 1934 had come to rival, in approach and in reputation, the celebrated E.E. 'Doc' Smith. (With his popular Lensman series, 'Doc' Smith had become the 20th century's first sf superstar.) At the height of his own popularity as a writer, Campbell joined the editorial staff of *Astounding Stories*, then the genre's top-paying magazine; a few years later, in 1937, he assumed its editorship. He remained in that position, through a number of title alterations and two changes of

Broke Down Engine

Unpublished, 1969
Pen & ink on scratchboard
Approx. 10in x 7in (25cm x 18cm)

Ron Goulart's collection *Broke Down Engine and Other Troubles with Machines* was so much fun to work on (see page 11) that I felt impelled to do a rather foolish thing – I went ahead and created an additional piece of art for the client for free! I was young and naive at the time (after all, it was my first book-cover assignment) and wanted very much to impress the publisher. There was talk of using the art as a frontispiece, or on the back cover, but that never happened. I believed then – and still do – that this was one of the very best drawings of my early career. The lesson I learned is that, in a business relationship, if one places no value on something it is thought of as worthless. The drawing has appeared often since then, and when I see it I always recall the wide-eyed wonder I had so long ago when the world of publishing was new and largely unknown to me.

ownership, until his death in 1971. Outwardly forsaking his writing career (but continuing to write under the pseudonym of Don A. Stuart, after the name of his then wife, Dona Stuart), Campbell focused most of his attention on his editorial duties, for more than three decades nurturing the careers of such genre notables as A.E. van Vogt, Robert A. Heinlein, Theodore Sturgeon, Isaac Asimov and Poul Anderson.

Despite his mastery of the written word and his vast knowledge of the genre, Campbell's tastes in art were extremely elementary and limited. He didn't believe, for instance, that the sky came in any colour other than blue, and he loathed what he pejoratively termed 'calendar skies'. He preferred scratchboard to virtually all other black-and-white media, and he focused his criticism of art almost entirely on its narrative content, seldom venturing to comment on drawing, composition or technique. He was also known to say, in exasperation, 'I don't really know what I want, but I'll know it when I see it.'

But there is more to my personal story and the circumstances of my early involvement with *Analog* than just my relationship with John Campbell. To begin with, it had never been my intention to be an illustrator. Throughout my years in public school it had been clear to everyone around me that I was gifted in the ability to draw, but I grew to resent the fact that I could do only this one thing well. I was the most mediocre of students in virtually every other aspect of my academic career. I did, however, love movies, and especially sf movies (a point I'll emphatically return to later in this book – see page 43), and by the time I was 8 or 9 that love had grown to be a consuming passion. In the early 1960s, as I stood on the threshold of

completing high school, there were only a handful of film schools in existence. Although I was accepted by the best of them, I couldn't afford to go to *any* of them. On the advice of my high-school guidance counsellor I entered a competition for a scholarship to a small, traditional New York-based art school called the Phoenix. After winning that scholarship, and with few other educational options open to me, I entered the Phoenix, kicking and screaming, in the Fall of 1963.

I graduated in 1967 and, after a year of teaching art in an elementary school in Larchmont, New York, I resigned to begin a stint in the US Navy. In the Fall of 1968 I married the girl I'd dated throughout high school and college, and in November that year I began my float training on the USS *Harris*, a destroyer escort that was docked at the foot of the White Stone Bridge. I'd managed to get assigned to the ship, which was only half an hour's drive from home, because my wife, Roseanne, was due to enter hospital at about that time for a biopsy; even though I was billeted on the *Harris*, I was able to drive back and forth to visit her in the evenings.

While I was assigned to the *Harris* it was discovered that Roseanne had Hodgkin's Disease, a form of lymphatic cancer, and that she had only a few months to live. The next several months were difficult for us as Roseanne underwent treatment, and that period was further complicated by my need to seek a military discharge on humanitarian grounds so that I could attend to her needs for whatever time remained to her. A further consideration was her parents' desire that the truth of Roseanne's condition be kept from her. There were instances in which I received phone calls or letters that I had to lie about in order to insulate Roseanne from the truth, and the feelings of guilt simply added to my dire emotional state. More trying still was the necessity to carry on as

Broke Down Engine and Other Troubles with Machines

Macmillan, 1970
Acrylics and collage on illustration board
8.5in x 12.5in (22cm x 32cm)

The anthropomorphic design of the archetypal sf robot allows writers ample scope to dwell on the sometimes-troubling moral prospects of our future with sentient machines. The parallels to human slavery alone offer an enormous amount of grist for the literary mill. This particular robot is an android, a machine deliberately designed to look like us in order to promote a greater compatibility with human beings. This, my very first book-cover commission (although I'd done several paintings for magazines by this time), was given to me in 1969. It was more than a year, however, before the book, a collection of stories by Ron Goulart, was published.

LEFT

Wrong Attitude

Analog, 1971
Pen & ink and Instantex on scratchboard
Approx. 14in x 8in (36cm x 20cm)

Done for a short story by Joseph Green that appeared in the February 1971 issue of *Analog*, this was one of a handful of drawings I did in which I used a transfer texture called Instantex. The texture was mounted on a sheet of film and could be selectively placed on the drawing surface by applying pressure. I was so unsure of my ability to work in any line medium at the time that I relied on this product as a crutch through several assignments. In this instance I used it to create the rough uniform strokes that make up the sky. Soon I would realize that there's no texture that can't be achieved by more traditional and less expensive means.

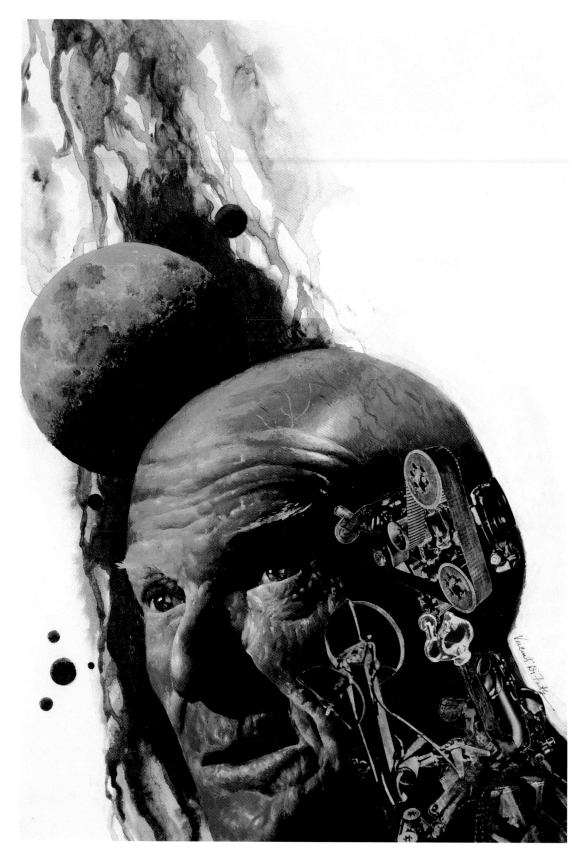

Pard

Analog, 1972
Pen & ink on scratchboard
*Approx. 13.25in x 8.25in
(34cm x 21cm)*

This illustration, one of the first I did for *Analog* editor Ben Bova after John W. Campbell's death, was for F. Paul Wilson's 'Pard', and appeared in the magazine's December 1972 issue. I always liked the clean, crisp look of its execution. Just when I was beginning to feel comfortable about my work, Ben and art director Herb Stoltz began pressuring me to change. Ben felt it was important to show that under his stewardship the magazine was about to take off in exciting new directions, and he wanted that reflected in every aspect of the publication, even the art. What followed for me was an awkward time of experimental and uneven output, but in the process I learned that I could do more if I just gave myself the chance.

RIGHT

A Voice is Heard in Ramah . . .

Analog, c1974
Pen & ink on Bristol board
*Approx. 14in x 8.5in (36cm x
22cm)*

Meet big-eyed, beautiful Rachel, born on October 25, 1741, who had seen many a hard time before making her way to Callahan's Place in this charming story by Spider Robinson. Callahan's was always filled to the rafters with fascinating characters from every corner of time and space, and I always looked forward to getting these assignments. At the time I was too focused on improving my craft to appreciate the fun I should have been having in the process. Each new job held unique challenges and, with them, endless possibilities for self-torment. The art was done on Bristol board with brush and pen in a – for me – fairly freewheeling style.

if nothing were wrong, while I was almost literally dying inside.

I applied for and was granted an extended emergency leave from the Navy while my request for a discharge was pending. With that came the need to seek gainful employment. By colossal good luck, I landed a job at Krantz Films, working in the background department for *Spider-Man,* an animated show that aired on ABC-TV on Saturday mornings. My advance-

ment at the studio was swift, especially when my drawing abilities were discovered, and I was transferred to the animation department, where I worked as an in-betweener. (An in-betweener – technically an assistant animator – is an individual who takes the animator's initial 'start' and 'stop' drawings, cleans them up, then draws the pre-determined in-between positions that will give the characters the appropriate illusion of motion.) Our producer was Steve Krantz, the husband of best-selling novelist Judith Krantz, and our director was Ralph Bakshi, best known for his X-rated feature-length cartoon *Fritz the Cat* (1972) and for a 1978 animated film adaptation of J.R.R. Tolkien's *The Lord of the Rings.* While things at home were far from ideal, it looked as if I had found a niche in animation that might eventually lead me to a career in film, which had been my true ambition all along.

So it seemed until I picked up a copy of the *New York Times* one Sunday morning to read a scathing editorial attacking the level of violence in children's programming. The editorial singled out *Spider-Man* as a chief offender; while there may have been merit to these concerns, the show looks remarkably mild by comparison to today's infinitely more brutal kiddie fare. The following Monday, ABC, which had been under

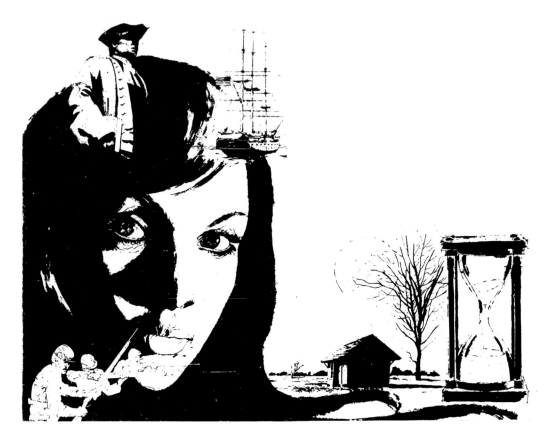

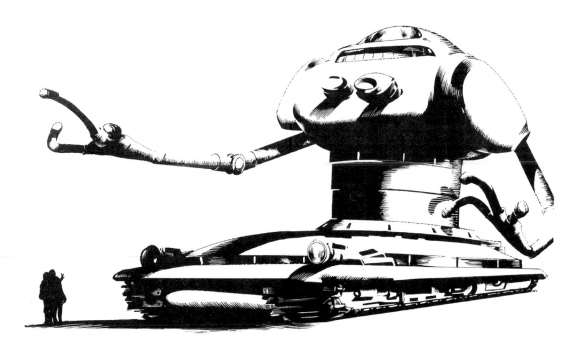

Gottlos

Analog, 1969
Pen & ink on scratchboard
Approx. 13in x 7.5in (33cm x 19cm)

My first year as an illustrator was an uncertain one. John W. Campbell, the editor of *Analog* – and almost certainly one of the most influential figures in sf literature during the 1940s and 1950s – had faith in me, even when the drawings I did were not very good. 'Gottlos' was the first cover I did for the magazine and, although neither the painting nor the interiors were especially good, there lurked within these images the beginnings of the artist I would eventually become.

great pressure to improve its overall ratings, cancelled the show. Not having been at the studio quite long enough to qualify for my union card, I was the first member of the staff to be let go.

And so it was that, the week before Thanksgiving 1968, I found myself besieged by the worst problem I could imagine and was also suddenly without a source of income. I was so traumatized by what was going on in my personal life and so naive in the ways of the adult world that I came to believe I was somehow personally responsible for the failure of *Spider-Man*. Humiliated by that first firing of my life, I never went back to collect my last week's paycheck, even though we desperately needed the money.

By December I was beside myself, for there were simply no staff jobs for illustrators to be had. Accordingly, I called Kay Tarrant, Campbell's editorial assistant at *Analog*. Although *Analog*'s glory days were behind it by the late 1960s, it was still considered the genre's top magazine. I asked Ms Tarrant for an appointment to show my portfolio, hoping to get some freelance work to tide me over while I hunted for more stable employment. I finally met with John Campbell in the week between Christmas and New Year's Day, and on the first work day of 1969 I was summoned to his office to receive an assignment.

I don't remember what the titles of those first stories were, because they were kept in inventory for a while and then published out of the sequence in which they were given, but by the summer of 1969 I was a published illustra-

tor. The seventy-five drawings I produced for Campbell during that first year with *Analog* were consistently awful, but I learned to work within the limitations of black-and-white media rather quickly. I did only one colour cover for the magazine during that time (given to me during a phone conversation with Campbell on the day after the first lunar landing in July), and the painting I produced was poorer than even the most abysmal of my black-and-white drawings. Why? More than likely my emotional state worked against me. Making matters worse was Campbell's inability to explain clearly what he expected of me.

Gradually, however, my work improved. Campbell somehow had faith in me, and I learned a great deal from him about narrative picture-making – things that even he could not have been fully conscious of. While I managed a brave front and no one outside my immediate family knew what was going on in my personal life, I often wondered if Campbell somehow suspected how pathetic my circumstance really was and kept me busy merely out of sympathy.

In my second year I turned a corner and, although I did only about half the number of assignments for *Analog* as I had in the previous year, my drawings greatly improved and I succeeded in expanding my client base. I was now working for virtually all of the genre magazines and was painting book-cover art as well. I also received my first Hugo nomination for Best Professional Artist.

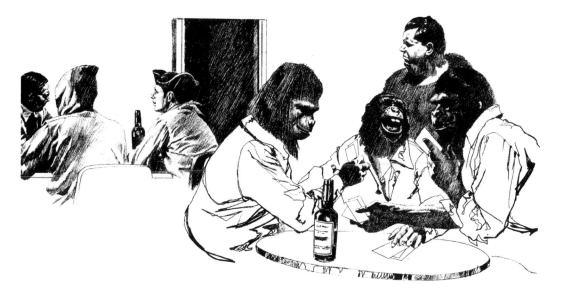

Unnatural Causes
Analog, c1974
Carbon pencil on gessoed board
Approx. 18in x 10in (41cm x 25cm)

After thirty years it's hard to remember much about the specifics of this Spider Robinson story, set in that now famous watering-hole of space and time, Callahan's Place. I do know it involved a Halloween party to which not all the patrons came in costume – nor did many of them need to. Of course, that's nothing new for a gathering at Callahan's, where aliens and time travellers have been known to cross paths. And then there was that mysterious series of earthquakes . . .

In an attempt to enliven the look of my work for *Analog* I tried a variety of approaches, especially on this particular series. The carbon pencil was an efficient medium and reproduced better than many of the other halftone techniques I tried during this frantic period of experimentation. Surprisingly, readers of the magazine were quite vocal about their preference for my scratchboard drawings, so the experiments were short-lived. When I expressed disappointment at the negative response, editor Ben Bova reminded me that, if the readers didn't react to what I was doing, I was probably putting them to sleep.

Campbell was famous for his protracted lectures, and the one lecture that has stuck with me over the decades involved a drawing I did in that first year for a Jack Wodhams story entitled 'Wrong Rabbit'. The story dealt with a hideous alien that gets caught in a teleportation beam and inadvertently transported to Earth. It seemed to me that the requirement of the assignment was to visualize the creature, and thus I produced a drawing of it trapped inside a teleportation tube. Campbell took a look at it and, after a long pause, said it was OK but that we needed to talk about it further. His body language made it clear that my handling of the assignment did not especially please him.

He started by asking me if I'd ever read his story 'Who Goes There?'. Of course I had, and I was delighted by the prospect of discussing it with him. (The story deals with a scientific expedition to the South Magnetic Pole and the discovery of a crashed spaceship and its occupant.) Next he asked me to describe the alien. Well, certainly I could do that. Campbell's description was quite vivid and very specific – one

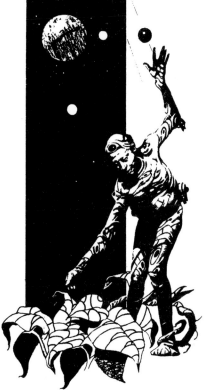

LEFT
Man with Plant
Analog, 1971
Pen & ink on scratchboard
Approx. 8in x 11.25in (20cm x 29cm)

This small drawing was created in 1970 when I was trying to settle on a reliable black-and-white technique. It appeared in the February 1971 issue of *Analog* illustrating Howard L. Myers's story 'Polywater Doodle'.

LEFT
Showboat World
Pyramid, 1975
Acrylics on illustration board
10.25in x 14.25in (26cm x 36cm)

I don't often paint on illustration board these days because of the occasional unreliability of the surface, but there was a time when I liked the way it absorbed the paint and muted the colours to produce, for instance, more naturalistic flesh tones. This novel was a sequel to Jack Vance's classic *Big Planet* (1957). The cover was done in a rush for a publisher now long gone, but I recall that it was a pleasure to work on this assignment with people I liked and to deal with clients who understood and appreciated my efforts.

and a half metres tall, three angry red eyes, hair like blue snakes and, and . . . I knew there was more, but I just couldn't put my finger on it.

In the story, beyond those few basic facts, Campbell goes on at length about the alien's unusual blood chemistry. The novelty of the idea that its individual cells can work independently of each other is so bizarre that the reader emerges with a compelling and thoroughly persuasive illusion of the creature's strangeness,

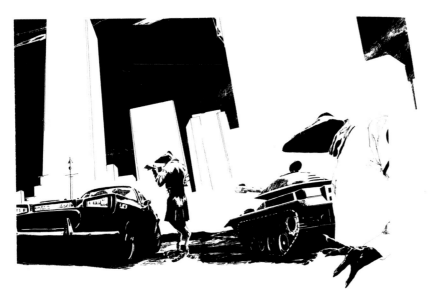

Shark-headed Aliens

Analog, 1972
Pen & ink on scratchboard
Approx. 16in x 9in (41cm x 23cm)

This was done for the Vernor Vinge tale 'Original Sin', which appeared in the December 1972 issue of *Analog*. The story had to do with the invasion of Earth by aliens with human torsos and heads like sharks. This was before the release of the movie *Jaws* and the wild *Saturday Night Live* parody with the 'land shark'; even so, I haven't been able to look at this picture since without giggling.

RIGHT
Bomb Scare

Analog, 1970
Pen & ink on scratchboard
Approx. 14in x 8in (36cm x 20cm)

This was done for the Vernor Vinge story 'Bomb Scare', which appeared in the November 1970 *Analog*. It was one of those rare instances in my early career when I was given something unusual and interesting to draw, rather than a thirty-page story of talking heads. I now suspect Campbell was testing me by giving me the most non-visual stories he could find. Not that I'm complaining, mind you, for from adversity comes character and as a young man I had loads of it!

without much visual description. The illusion is remarkable, but that's all it is – so much smoke and mirrors.

Campbell believed that everyone has a different idea of the things he or she fears the most. By providing only the most minimal details, much of the process of imagining what the thing looks like takes place in the mind of the reader.

And so I learned about the importance of what is seen in the mind's eye. For the generations that grew up with radio, where things were *heard* and not seen, the power of suggestion by means other than sight was well known. As a reader I had an inkling of this, but, for a guy who had been weaned on television, the realization of just how potent that power could be was truly a revelation.

As we continued to discuss the story, I asked him what he thought of the 1951 Howard Hawks film adaptation of his story – *The Thing from Another World*, one of my favourite 'Golden Age' sf movies. He thought it was fine, appreciated the fact that it was regarded as a 'classic', but was deeply disappointed that it 'wasn't his story'. His story had been about the ultimate invader – an enemy so perfectly adapted to survival that it could alter its appearance to look like anyone or anything. It could go anywhere, assume any form, and thereby find refuge by hiding in the open. As it consumed its victims it could reproduce itself by absorbing the mass of its prey, then using that additional mass to produce other shapeshifting individuals. The fact that the cells of the creature, imbued with a collective consciousness and a fanatical instinct

to survive, could function independently made it virtually indestructible. And it was telepathic, too: it could change itself to look like your best friend and, by reaching into your mind, it could extract information about the behaviour and responses you'd expect so as to give the outward appearance of normalcy. The fact that Hawks abandoned this theme of shapeshifting divested the story of its essential novelty and deprived the viewer of participating in one of the greatest sf mysteries ever written, for in knowing of its blood chemistry we are provided with the key to its vulnerability. What remains in this first screen version of 'Who Goes There?' is a compelling atmosphere comparable to the original, yet with a story reduced in most of its aspects to the conventions of the modern horror film.

What have helped to elevate *The Thing* to its classic status are the crispness of its direction and the extraordinary performances of its ensemble cast. The fact that the Thing is from outer space is the only true link the film has to sf. In many ways the staging of the action, the creature's appetite for human blood and its presence ever shrouded in darkness give this adaptation the characteristics of a traditional vampire movie.

Nearly as astonishing as Campbell's story itself was its source, for it derived from his own life experience. His mother and his aunt were identical twins, and his aunt sometimes passed herself off as her twin sister. As a child, Campbell must have been terrified by the deception that the one being in his young life in whom he needed to place absolute trust might not be what she seemed. It had given him the passion to pen one of the great works of sf literature and, although much of its language now seems no longer fresh, it still manages to generate thrills some six decades after it was first published.

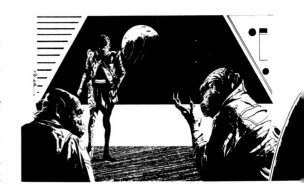

☆ ☆ ☆

These sessions with Campbell, though sometimes made intimidating by his disarming directness, provided me with a remarkable, free and invaluable education. They went on for nearly two years until Campbell's unexpected death from a heart attack in 1971. Although we knew each other only in the context of our business relationship, I felt I had lost a friend and a mentor with his passing. At his memorial service his widow, Peg, came up to Jack Schoenherr and myself and told us how fond Campbell had been of both of us, and how he had regarded Jack as the son he'd never had. In the parking lot later Jack confessed that he'd always felt Campbell barely tolerated him.

There were *always* changes to be made on the drawings I brought in to Campbell, but scratchboard made most of the alterations relatively easy. Scratchboard is a drawing surface of compressed white clay on board to which ink is applied and then selectively scraped away. Because of the thickness of the clay, an area can sometimes be changed more than once to achieve a desired effect. But, after more than thirty years at it, I must confess I'm still very much a novice. The masters of the medium were people like Virgil Finlay and Jack Schoenherr, to whom I can hardly hold a candle.

The drawings presented here are not so much what I believe to be the best of what I've done in black-and-white media but, rather, all that remain to me after years of neglect. I've taken these illustrations for granted, sold many of them off and destroyed many more. Although I still do them – now almost entirely out of a sense of loyalty to the magazines that were so much a part of my early years – they are a reminder to me of my difficult and uncertain beginnings. They are also, in a more positive light, irrefutable evidence to me that the human spirit can prevail through even the worst of circumstances.

As a footnote to all of this, I should add that Roseanne, my dear wife of thirty-four years, is still very much alive despite the direst of predictions. We've since had two sons, of whom we're immensely proud, and her health, although rocky at times, has been relatively stable. And in this there is yet another lesson learned: that, even if it seems like the sky is falling, sometimes it doesn't.

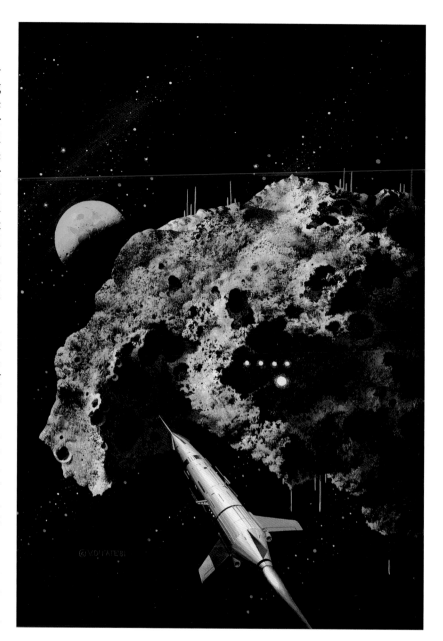

Through the worst of times science fiction has always been there to offer me comfort and to provide me with refuge from life's hardships. I love its high adventure, its distant and eternal horizons, its power to transport me to places that my eyes have never seen and where my need to reach the journey's end can be satisfied. It is unlike any other kind of storytelling that I know. After so many years of relying on it and working at it, I can't imagine what my life would have been without it. It has filled me at times with fear, but also with wonder and joy, and with the one feeling that I've come to value above all others – hope.

Passer-by

For *The Other Side of the Sky*, New American Library, 1980
Acrylics on hardboard
11.5in x 18in (29cm x 41cm)

Not long after I finished the covers for New American Library's Heinlein series I got another great assignment, this time to work on a book series by Arthur C. Clarke. Of the story collections included were two of my favorites, *Islands in the Sky* and *The Other Side of the Sky*, both of which I'd read as a youngster. 'Passer-by' is a subtle tale of men from Earth encountering a strange asteroid as they zip about the cosmic neighbourhood. A briefly glimpsed row of lights indicates an alien presence as the asteroid's dark, craggy bulk goes by.

GADGET MAN

W<small>ITH THE DEATH</small> of John W. Campbell Jr in 1971, the Condé Nast Publishing Company began an intensive search to find a suitable replacement for him at *Analog*. Rumour had it that such notables as Isaac Asimov and Lester del Rey were among the first to be approached. The man who finally landed the editorship was a personable 39-year-old author named Ben Bova. Ben had significant experience as a science writer and editor, and had worked previously in the aerospace industry on the Vanguard Project and at the Avco-Everett Research Laboratory. He was a quick study, and in no time successfully revitalized the magazine by bringing in stories with a decidedly sociological slant while at the same time keeping faith with *Analog*'s longstanding editorial preference for hard sf.

At first Ben and I really didn't know what to make of each other and, I'll admit, I was a bit brash in dealing with him. He knew nothing about art and he deferred a bit too often – or so I thought – to *Analog*'s art director, Herb Stoltz. Herb, in contrast, knew quite a bit about art but nothing at all about sf. Campbell had been active in every aspect of the magazine, including its artwork, and Herb, who had responsibilities with other Condé Nast magazines, had been only too happy to let him run the show. But with Ben things were different. Ben wanted Herb's input, and was eager to express the changes in the magazine's direction through a radical shift in its most visible element, its art. Whereas Campbell had had a clear predilection for scratchboard for the magazine's interiors, Ben and Herb were open to a freer line treatment of the black-and-white illustrations and were even receptive to the use of halftone.

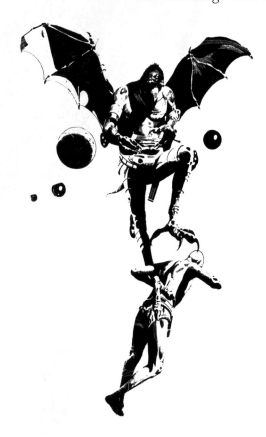

The cover art, however, became a matter of contention. There was a marketing director at the company, 'Doc' Yound, who'd been keeping statistics on all the Condé Nast magazines and had charted their individual ups and downs. Yound was convinced that, when *Analog* ran a cover painting of a spaceship, a robot or some other kind of futuristic gadget, the newsstand sales increased. I had never encountered marketing people before, and the thought that a single formula could act like a magic bullet to attract readers didn't seem reasonable to me. I had been taught, and still fervently believe, that human beings crave variety in their art, even if they need stability and

familiarity in their personal lives. Whether or not Yound's beliefs were true, what mattered most was that *he* believed in them, and thus *Analog* embarked on its gadget-of-the-month campaign – one that began in the early 1970s and still endures to this day.

By the time *Analog* formulated its new cover policy, my paperback clients had long typed me as a 'gadget' artist. When I entered the field in the late 1960s, sf literature was in transition. The British magazine *New Worlds*, under the skilled editorship of Michael Moorcock, had become decidedly avant garde in its approach to sf, and the impact of this effort had sent shock waves through the field. Stories were no longer quite so simplistic in their approach to conflict and characterization, being instead fraught with moral and psychological ambiguities. Soon writers on both sides of the Atlantic were producing stories with a greater emphasis on style and experimentation. Many of the works, particularly those by US authors of draft age during the Vietnam War or who had returned from that war transformed by their experience, were negative in their views of science and of the human condition. These attitudes in many ways resembled those of the artists and writers during World War I who had founded the Dadaist movement – although sf's New Wave lacked a uniform doctrine and comparable organization.

Along with this new artistic sensibility came a widespread recognition of the genre in academic circles. Suddenly high schools and colleges all across the USA were offering courses in sf, and book publishers began to package their sf titles with more sophisticated artwork in anticipation of this expanded interest. Because so much of the literature had taken a negative turn, the images of Surrealism seemed an appropriate fit, and the bookstores were suddenly awash with the dynamic cover art of people like Don Ivan Punchatz, Leo and Diane Dillon and Robert Pepper. Thus I graduated from art school with the expectation that this would be the kind of imagery I would be creating.

But, by the time I got around to showing my portfolio, the marketing strategy for sf's New Wave had proven to be a disaster. Packaging books with the unsettling imagery of Surrealism, far from attracting readers, drove them away. Once the failure of the strategy was known, publishers responded quickly, and sf art returned to its more traditional roots. Cover art became more literal, more narrative, more pulp-like. Editors, long ignored by art directors, were finally given a degree of control in the

LEFT AND ABOVE
Flight/Attack
Analog, 1971
Pen & ink on scratchboard
Approx. 7in x 10in (18cm x 25cm)
Approx. 14in x 8in (36cm x 20cm)

In my second year of working for *Analog* I was fortunate enough to get some very interesting stories – unlike my first, when I merely got the stories that no other illustrator wanted to do. It wasn't that the first year's stories weren't good, it was that many of them simply weren't visual and thus required considerably more time and effort to illustrate. These two drawings appeared in the July 1971 issue of *Analog* for 'A Little Edge', a wonderful tale by the talented William E. Cochrane, who used the conspicuous pseudonym S. Kye Boult. The bird-headed creatures are members of a predatory race that wages a seemingly endless war against the other intelligent but considerably weaker species on their home world.

selection of art (although that wouldn't last very long). The first assignments I was handed required that I paint spaceships.

I had no idea of how to do such a thing, but in time I became proficient at it – so proficient, in fact, that I'm hardly ever asked to do anything else. I'm not complaining, mind you, as painting gadgets has put my kids through college and kept me in beer money all these years. But I do sometimes wish I could more often get to paint a pretty face, or even an ugly one – or simply something with any kind of face at all.

The Best of Philip K. Dick
Ballantine/Del Rey, 1977
Acrylics on hardboard
10in x 17in (25cm x 43cm)

I was excited to receive this assignment, as Mr Dick was one of my favourite sf authors. His stories usually focused on the subjective nature of reality and, although no one would ever make the mistake of calling him a hard-sf writer, his fiction was rooted in a clear understanding of quantum physics and, especially, in the puzzling 'observer effect'. It came as no surprise, given Dick's predisposition, that he was lured into the use of hallucinogenic drugs during the wild and woolly 1960s, a slip that derailed his writing career for nearly a decade. *The Best of Philip K. Dick* came near the start of his triumphant return to writing, and was a collection of his earlier short fiction. The particular story that inspired this cover painting was 'If There Were No Benny Cemoli', which deals with the return of interstellar travellers to a war-torn and nearly devastated earth.

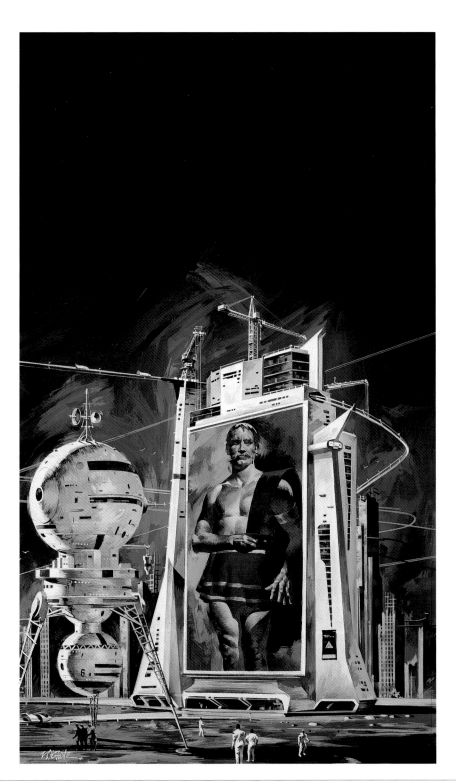

FACING PAGE
Putting Up Roots
Tor, 1997
Acrylics on hardboard
Approx. 16in x 24in (41cm x 61cm)

This was a novel written for the *Jupiter* series by the brilliant Charles Sheffield. The series was meant to follow in the footsteps of the great Heinlein and Asimov juveniles of an earlier generation, and most of the stories had youthful protagonists. The contraption depicted puts in the briefest of appearances somewhere near the novel's conclusion.

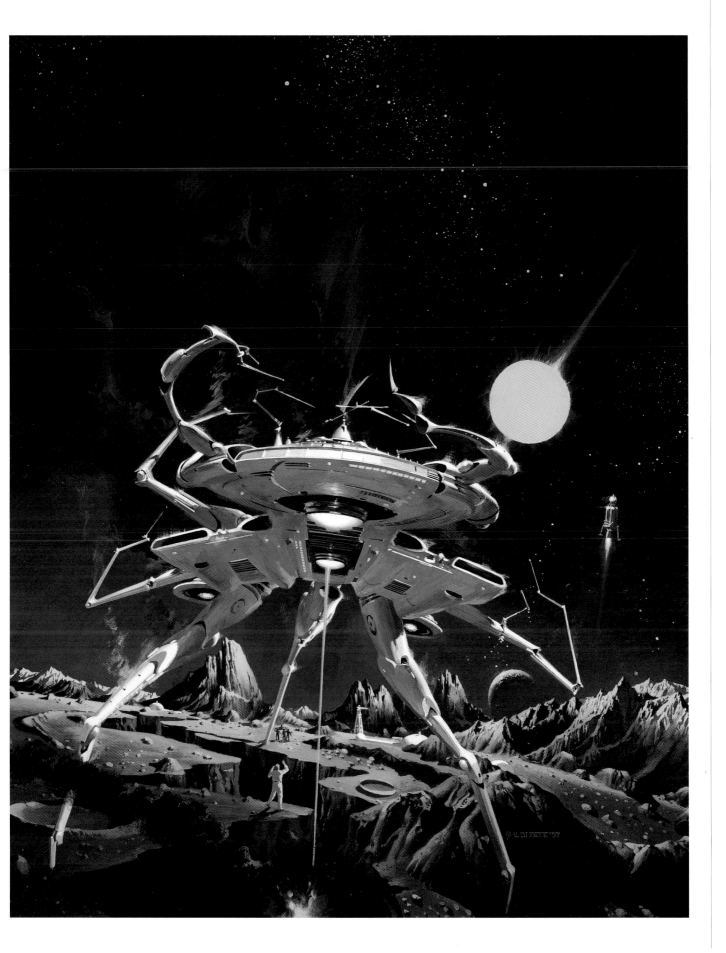

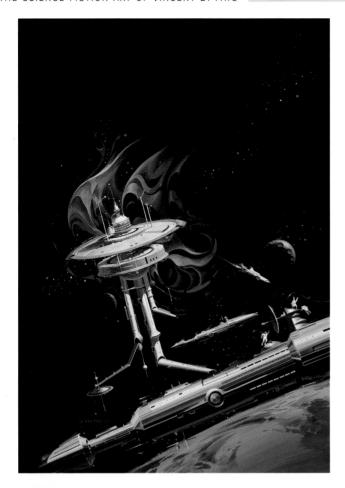

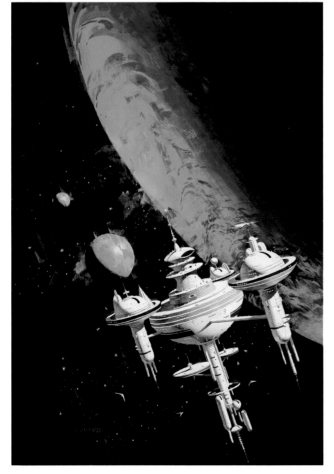

LEFT
Forward in Time
Fawcett, c1983
Acrylics on hardboard
13.5in x 19in (34cm x 48cm)

Ben Bova is a well regarded author of sf stories and of award-winning books on science, and was formerly the editor of *Analog* and then *Omni*. Through much of our parallel careers, he's been a valued friend and a supporter of my work. This wonderful collection of his short fiction afforded me an opportunity to paint a space station that was not fashioned in the traditional, slowly revolving torus of 1950s sf.

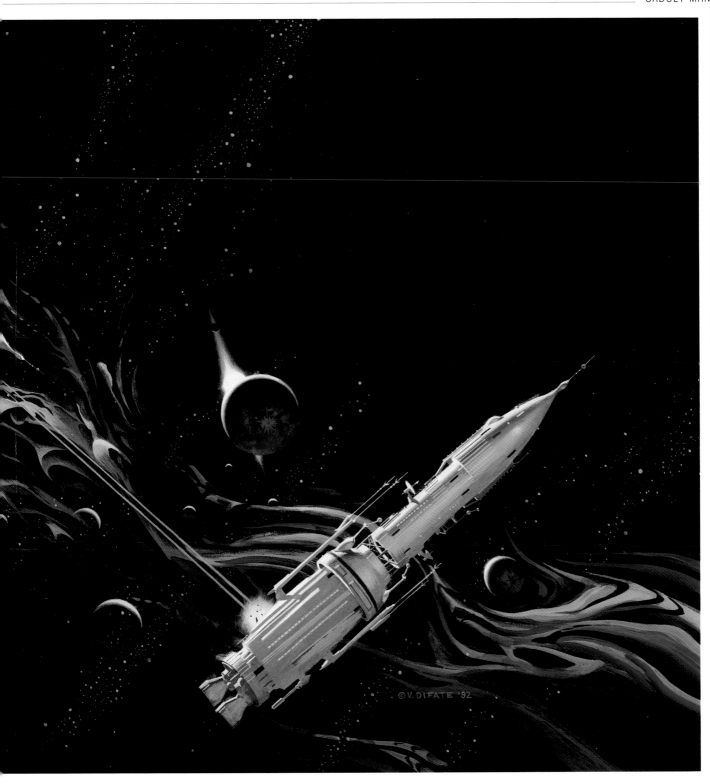

FACING PAGE, TOP
Radius of Doubt
DAW, 1991
Acrylics on hardboard
Approx. 15in x 23in (38cm x 58cm)

This was the first novel in the *Patterns of Chaos* series by the talented Charles Ingrid, the series title referring to a means of interstellar travel. The challenge for me was to come up with a motif that would represent the notion that space is a complex form bent in on itself.

ABOVE
Paths of Fire
DAW, 1992
Acrylics on hardboard
Approx. 24in x 16in (61cm x 41cm)

The second volume in Charles Ingrid's *Patterns of Chaos* series was relatively easy to illustrate, since the visual motif had been previously established. A ship, materializing out of the extra-dimensional void, fires on another.

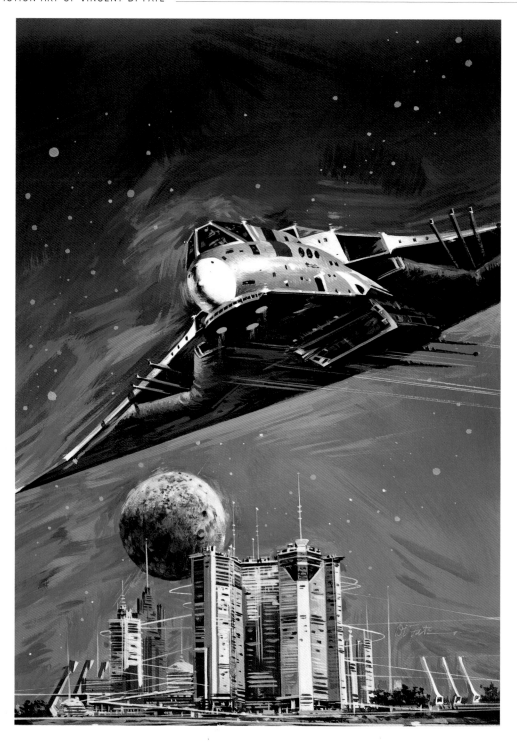

ABOVE
After the Festival
Analog, 1977
Acrylics on hardboard
Approx. 10in x 15in (25cm x 38cm)

George R.R. Martin's first novel, *Dying of the Light*, was initially serialized in *Analog* under the above title, during a time when the magazine was going through a 'machine of the month' phase. This wonderful, character-driven story had few gadgets in it other than this briefly described antigrav bat-winged air car. Mr Martin described the car as briefly as that, but, when we crossed paths some months later at an sf convention, he praised me for the accuracy with which I'd depicted it. It must have been the specific words he used that triggered such a vivid response in me, for I recall seeing it clearly in my mind's eye before beginning the painting.

RIGHT
To Bring in the Steel
Analog, 1978
Acrylics on hardboard
9in x 12.75in (23cm x 32cm)

This fascinating Donald Kingsbury story deals with the concept of asteroid mining. Asteroids are captured from the belt and outfitted with reactors that smelt down their raw materials while at the same time propelling them toward Earth. Once in Earth orbit the planetoids are stripped of their last usable elements. The central ship, the *C.L. Moore*, employs a solar-ion drive – a propulsion system in which charged particles are heated to a high exhaust pressure by lasers powered by a solar-energy collector at the ship's stern.

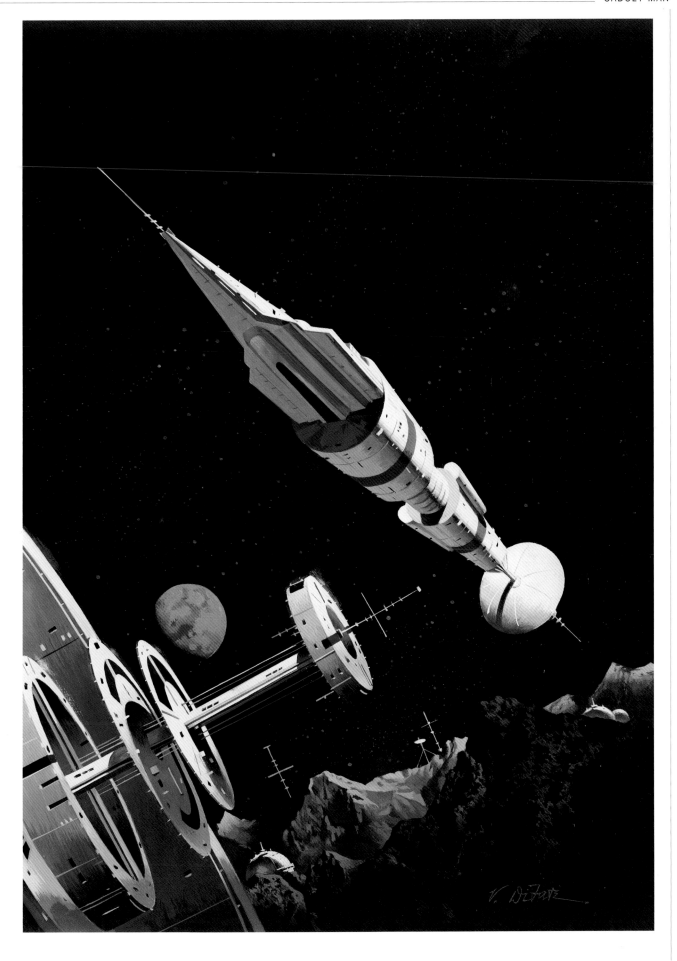

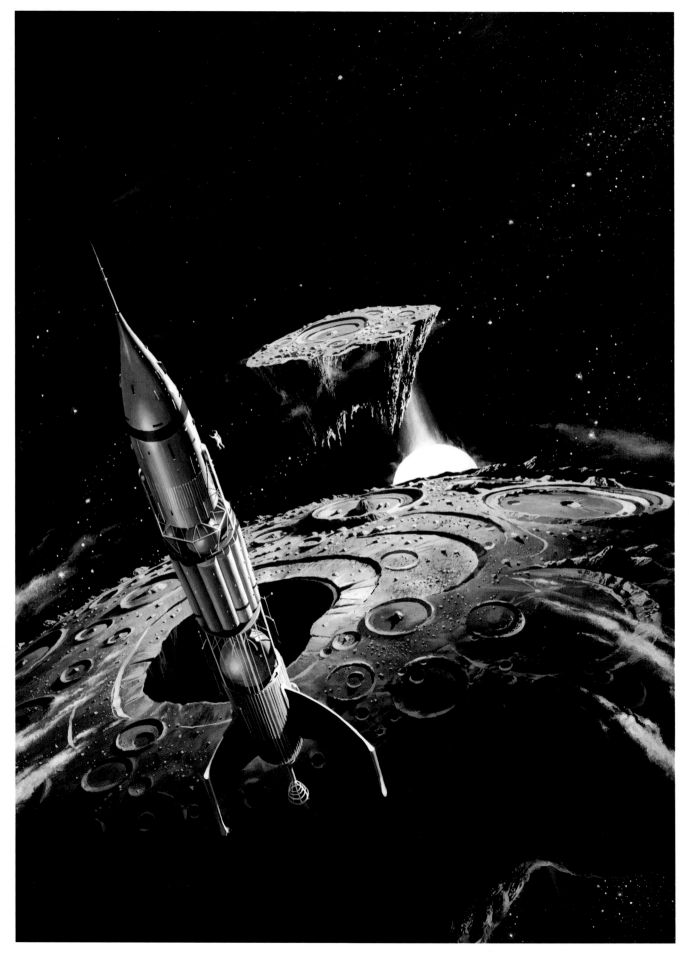

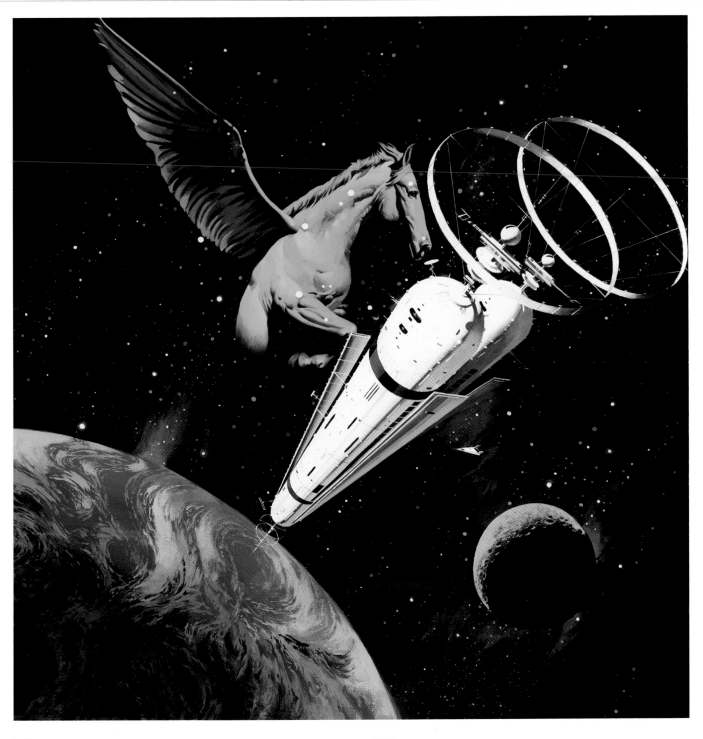

Star Fire
Tor, 1987
Acrylics on hardboard
15in x 20in (38cm x 51cm)

In this story by Paul Preuss, the *Star Fire* is a ship especially designed for asteroid study. While pursuing an asteroid, the ship gets trapped in the powerful gravity well of the Sun, threatening the crew with incineration. The resourceful humans have only one chance for survival – to dig a hole in the planetoid large enough to hold their ship.

Bellerophon
Cover for *Destinies 6* edited by James Baen, Ace, 1979
Acrylics on hardboard
Approx. 14.25in x 14.875in (36cm x 38cm)

Few would argue the point that, in US book publishing at least, the power of the art director has diminished considerably in recent years. This painting of an O'Neill-style L–5 space complex is a prime example of the power art directors used to wield. As one might readily deduce, the constellation Pegasus featured significantly in the story, but the art director insisted the constellation be shown backwards, so that it faced into the cover lines. Reality was accordingly altered. In the 1970s, rearranging the universe to suit the whims of a client was common – someone in my line of work often took it for granted.

Bright Angel
Ballantine/Del Rey, 1992
Acrylics on hardboard
20.5in x 40in (52cm x 102cm)

Derelict ships adrift in the frozen depths of space is a recurrent theme in space opera, but one I seldom get the opportunity to paint. This may not have been the best possible solution to this cover assignment for John Blair's novel, but it was certainly one with a strong dramatic element.

FACING PAGE
Antibodies
Worldwide Library, 1988
Acrylics on hardboard
16in x 24in (41cm x 61cm)

At what point do we become so 'plugged-in' to the cybernetic world that we cease to be entirely human and become . . . something else? The author of this novel, David J. Skal, is better known today as a leading authority on horror films, but he's one heck of a good storyteller, too. This novel deals with a youth culture in which youngsters indulge in self-mutilation in order to have their body parts replaced with electronic components.

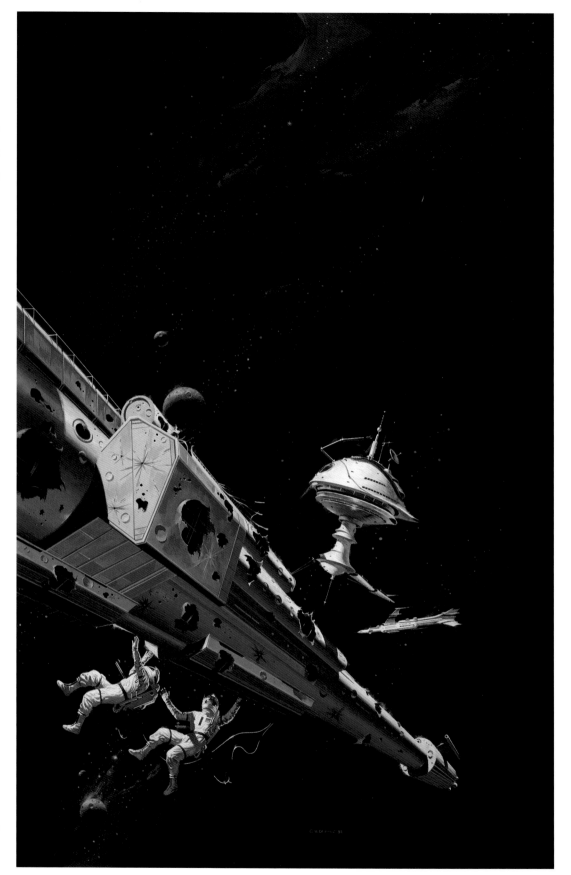

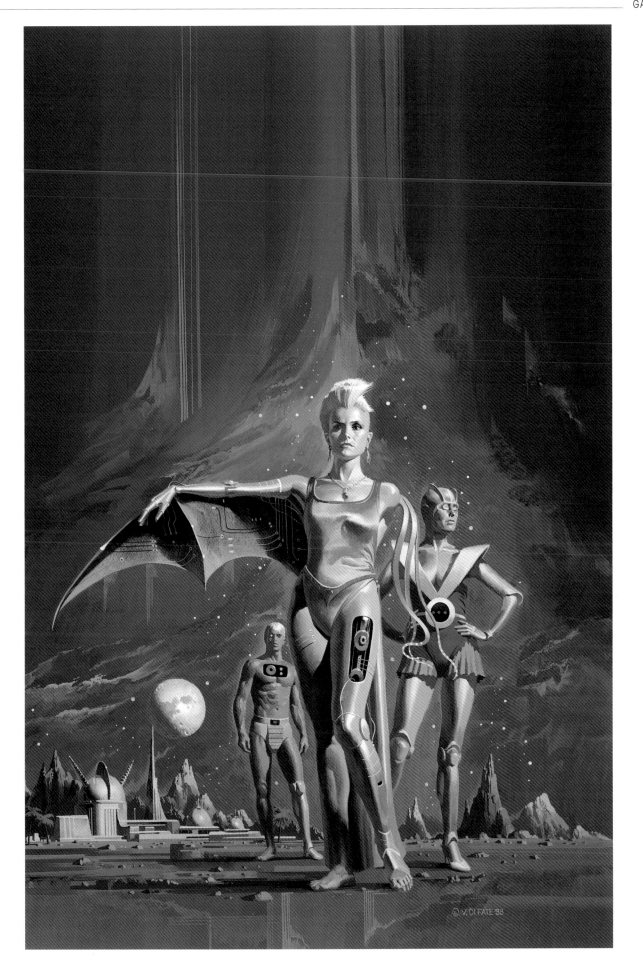

RIGHT AND FOLLOWING FOUR PAGES
Star Quest
Comic Images, 1995
Acrylics on illustration board
Each 9in x 6in (23cm x 15cm)

Comic Images published a collectors' trading-card set of my work in 1994 and called back a few months later to commission me (and a number of other artists) for the *Star Quest* game card series. Although my time was pretty well booked when the call came, the assignment intrigued me and I agreed to work on the project – although I had to produce three images per day in order to keep pace with the deadline. Given the time constraint, the results are rather interesting, I think, and proof that quality illustration is a matter more of inspiration than perspiration. These little paintings are easily as good as paintings I've spent days working on.

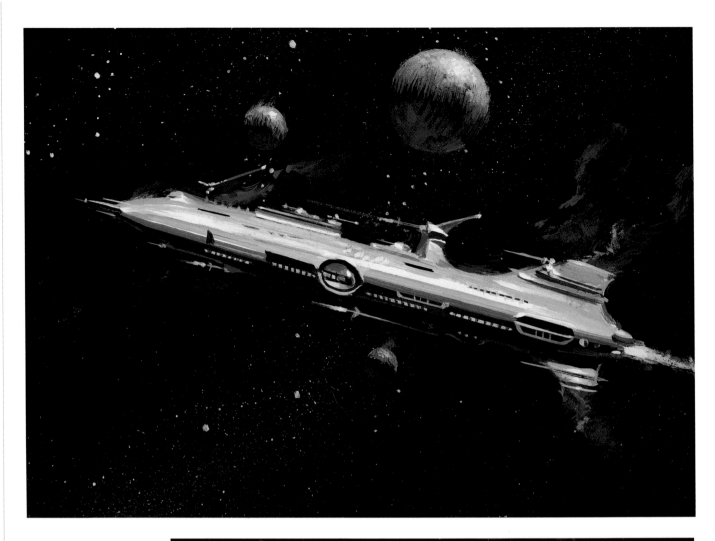

ABOVE, RIGHT AND FACING PAGE
Star Quest
Comic Images, 1995
Acrylics on illustration board
Each 9in x 6in (23cm x 15cm)

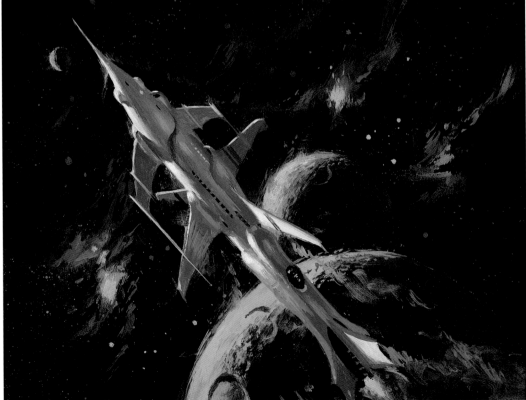

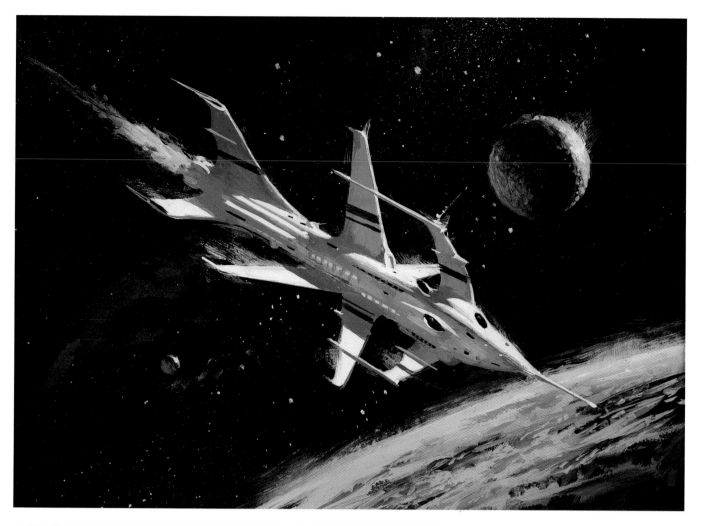

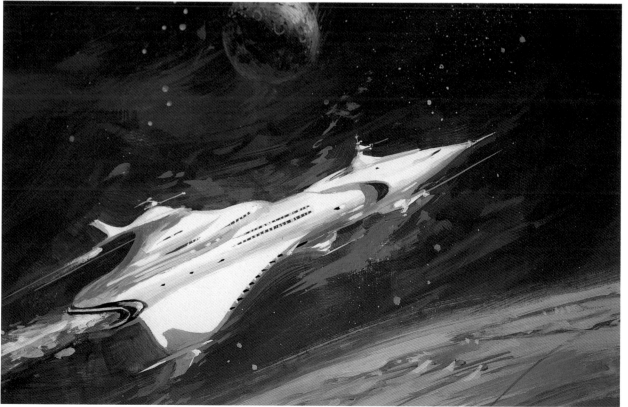

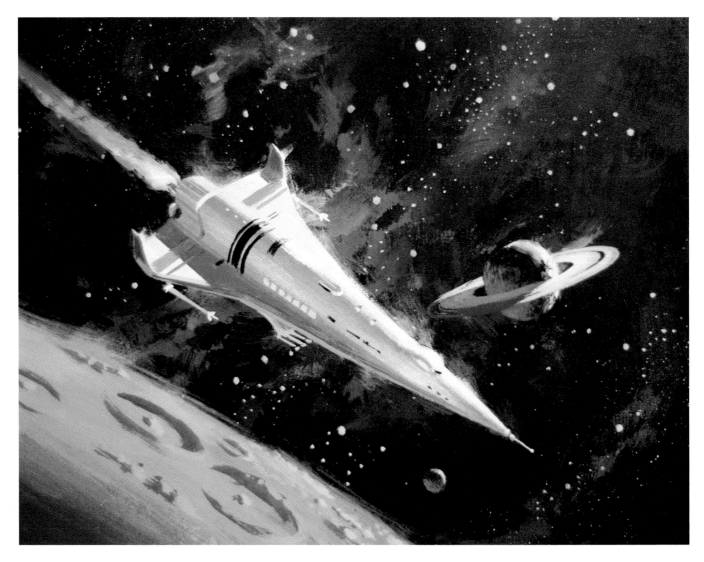

ABOVE AND FACING PAGE
Star Quest
Comic Images, 1995
Acrylics on illustration board
Each 9in x 6in (23cm x 15cm)

One of the more interesting challenges of this project was having
to create different generations of the same warships.

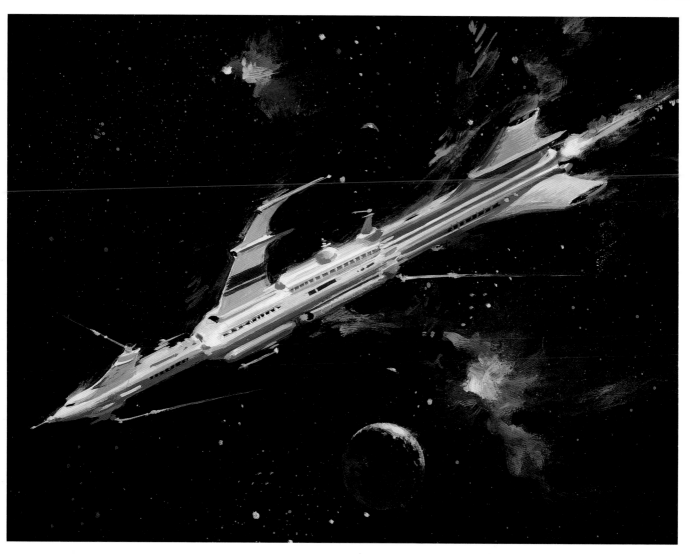

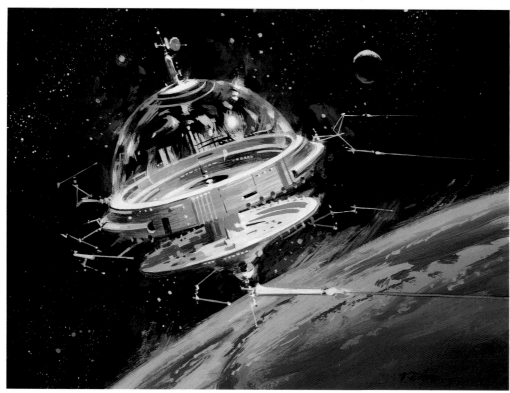

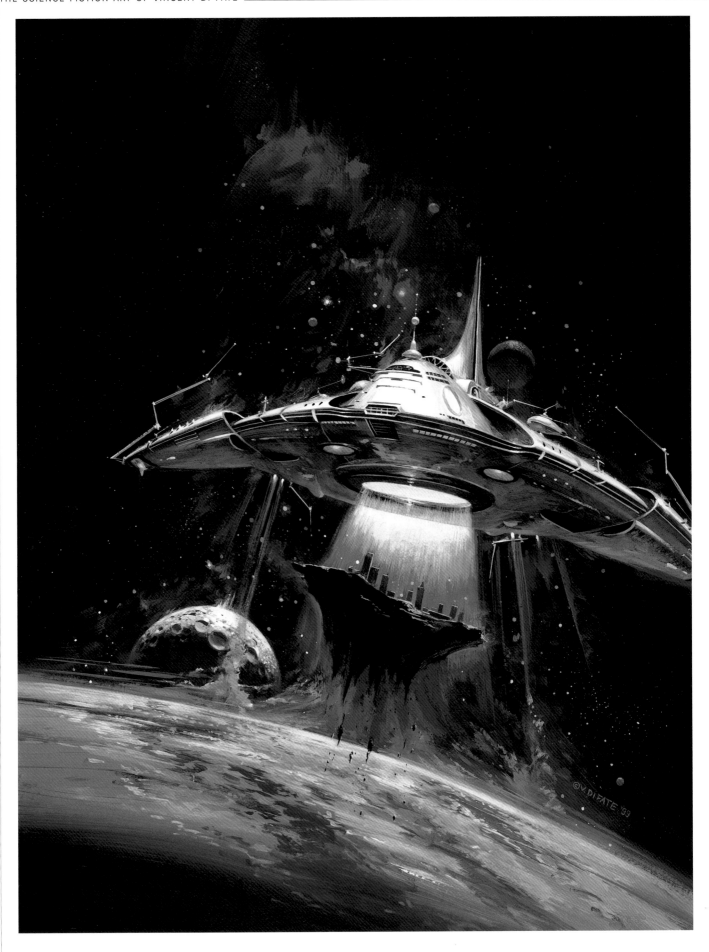

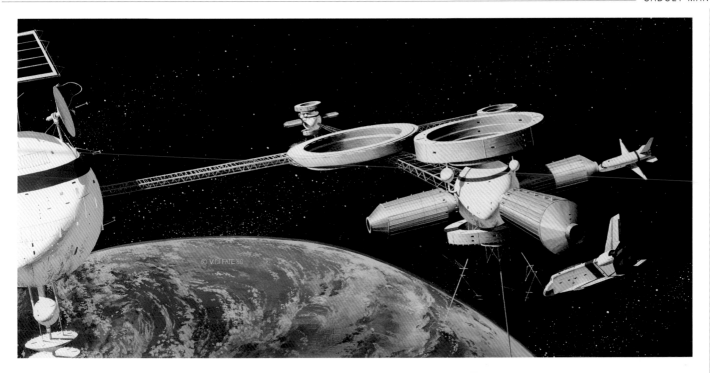

ABOVE
The Space Enterprise
Ace, 1980
Acrylics on hardboard
20in x 12in (51cm x 30cm)

This was one in a series of novels by Harry Stine dealing with space development in the near future. This particular image depicts a manufacturing complex where zero gravity allows the creation of unique products without wear from friction and other destructive gravity-related effects.

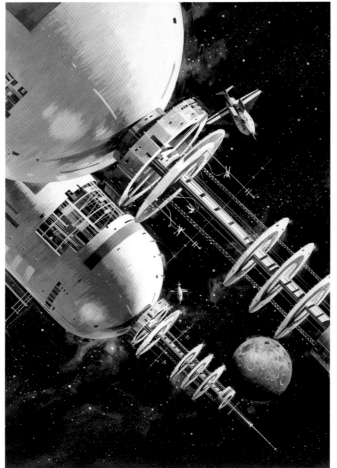

LEFT
The Good Stuff
Science Fiction Book Club, 1999
Acrylics on hardboard
Approx. 12in x 18in (30cm x 41cm)

Whenever I get a call for a 'generic' sf painting it affords an opportunity to visit themes that don't ordinarily come my way. In this particular case I'd been asked to create an album cover for the rock group Boston, and I came up with the concept of the city of Boston being lifted off the Earth's surface on a tractor beam by a huge alien spacecraft. For whatever reason the group decided to go another way with their album art, but the idea lingered in my mind as one I should eventually bring to a finish. Only a day or two passed before I got the call to do another 'generic' painting, this time for an anthology edited by Gardner Dozois. The idea was set, the sketch was done and only the city had to be changed for the final painting.

LEFT
Of Future Fears
Analog, 1977
Acrylics on hardboard
Approx. 13in x 18in (33cm x 41cm)

In the 1970s the idea of Gerard K. O'Neill's L–5 concept was still very much alive. L–5 was a proposed artificial world located at Lagrange point number five – a place between the Earth and Moon where the gravity wells of the two worlds cancel each other out. Mack Reynolds's novel *Of Future Fears*, first serialized in *Analog*, dealt with the issue of sabotage in such a complex.

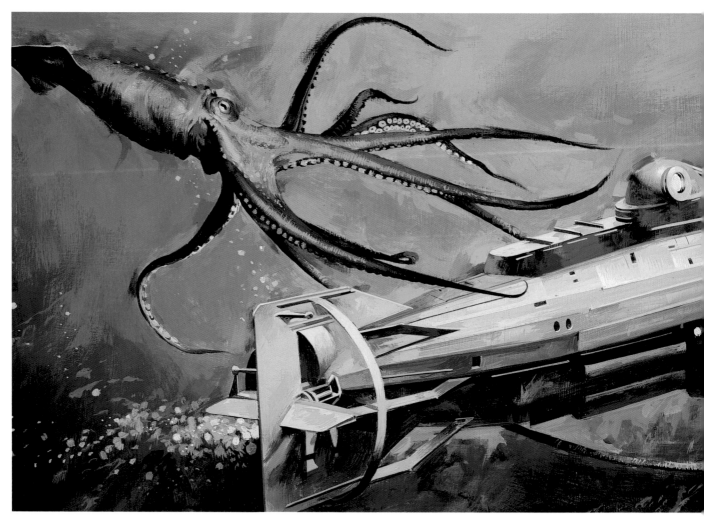

Nautilus

From *20,000 Leagues Under the Sea*, Workman, 1980
Acrylics on hardboard
21in x 9in (53cm x 23cm)

Jules Verne was a founding father of modern sf and almost certainly
the genre's first superstar. His classic 1870 novel of mad Captain
Nemo and his fabulous submersible ship, the *Nautilus*, is an
extraordinary exercise in extrapolative storytelling, and Verne gave
explicit details of his fantastic inventions. The *Nautilus* is 235ft (72m)
long. The largest known specimens to date of the giant squid, shown
here attacking the mighty vessel, are, however, only about 60ft (18m)
from tailfin to the tips of the longest tentacles. When I painted the
beast in its proper proportion, it ceased to appear threatening, so I
made it bigger. It has always bothered me that this painting does not
coincide with the facts, but subsequent attempts to revisit this scene
have proven to me that my initial instinct to exaggerate the size of the
beast was, from the standpoint of dramatic impact, essentially correct.

Nautilus Revisited

Unpublished, c1993
Acrylics on hardboard
20in x 8.25in (51cm x 21cm)

Descriptions of the squid attack vary in the different translations of Verne's novel. I attempted this painting hoping to compensate for a lack of size by an increase in number. To my mind, the creatures still fail to intimidate.

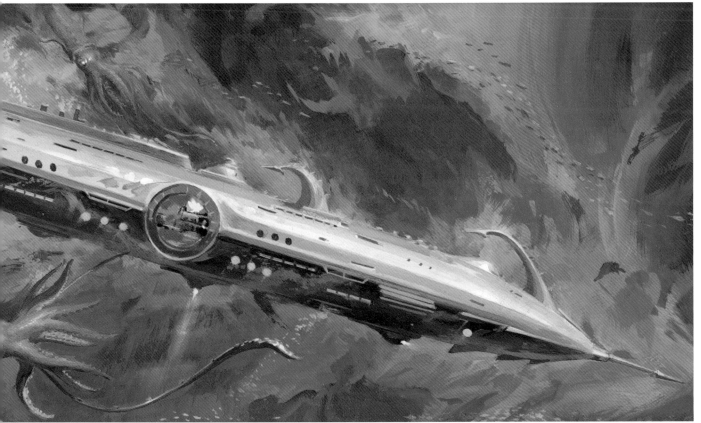

The Chaos Weapon

Ballantine/Del Rey, 1977
Acrylics on hardboard
9.25in x 16in (23cm x 41cm)

The author Colin Kapp is
known for his sweeping ideas.
The Chaos Weapon is an alien
artifact the size of a small solar
system. Powered by four black
holes contained in a cage at its
far end, it is illuminated by
four Sol-sized stars. It exists in
a nether realm between uni-
verses, and is used by its cre-
ators to wage war against
humanity by distorting
entropy, causing great calami-
ties to befall the human-popu-
lated worlds. The editor, Judy-
Lynn del Rey, wanted the
Chaos Weapon portrayed in
the cover painting along with
the protagonist, a middle-aged
fellow with an 'invisible' extra-
dimensional alien imbedded in
his shoulder. When light
struck the alien in a certain
way, the diminutive frog-like
creature would become briefly
visible. My job was simple –
show the weapon in its uni-
verse-smashing enormity, the
hero, his invisible companion
and his comrades, all in the
confines of a painting that
would be shrunk to a 4in x
7in (10cm x 18cm) paperback
book cover!

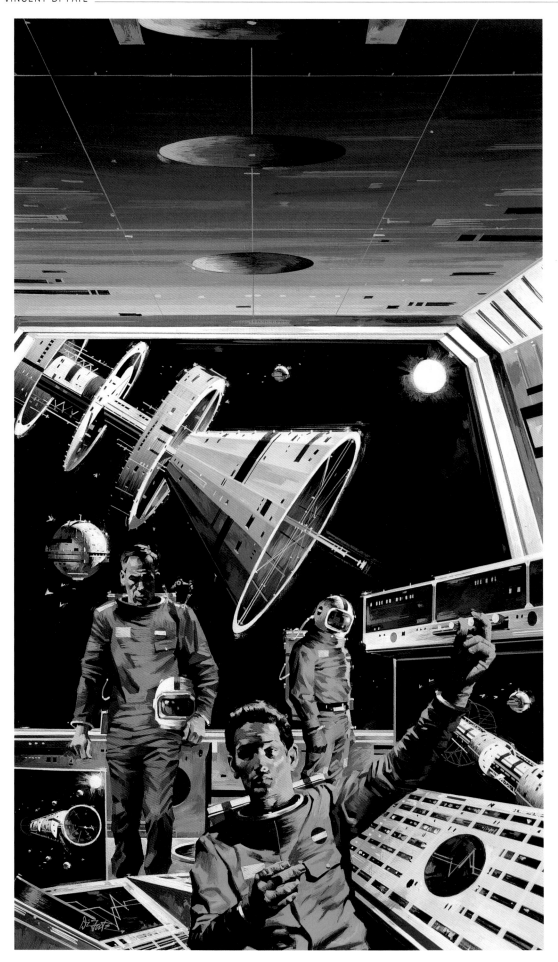

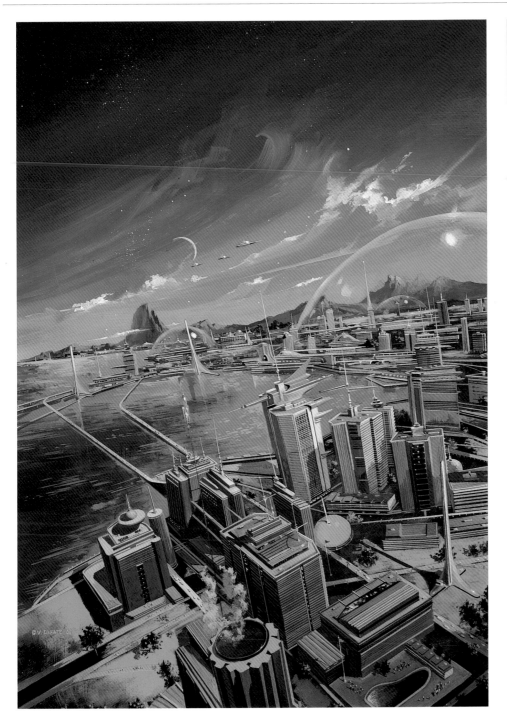

50 in 50

Tor, 2001
Illustration: Acrylics on hardboard;
13.5in x 19in (34cm x 48cm)
Sketch: Acrylics on Acryla-Weave;
6.75in x 11.25in (17cm x 29cm)

This cover painting, for a collection of
stories by Harry Harrison, afforded me a rare
opportunity to depict a futuristic cityscape.
I created the sketch (above) on a Sunday
afternoon, aimlessly filling up a full 16in x
20in (41cm x 51cm) sheet of Acryla-Weave
(a canvas-like material especially formulated
for use with acrylic paints), and finally
decided to focus on a small portion of the
art for my finished painting. By cutting a
mat in proportion to the finish, I was able
to move about the entire picture and isolate
its most interesting elements, and decided
on the tilted point of view. The tilt gave an
otherwise passive assemblage of vertical
and horizontal shapes an enhanced visual
dynamic.

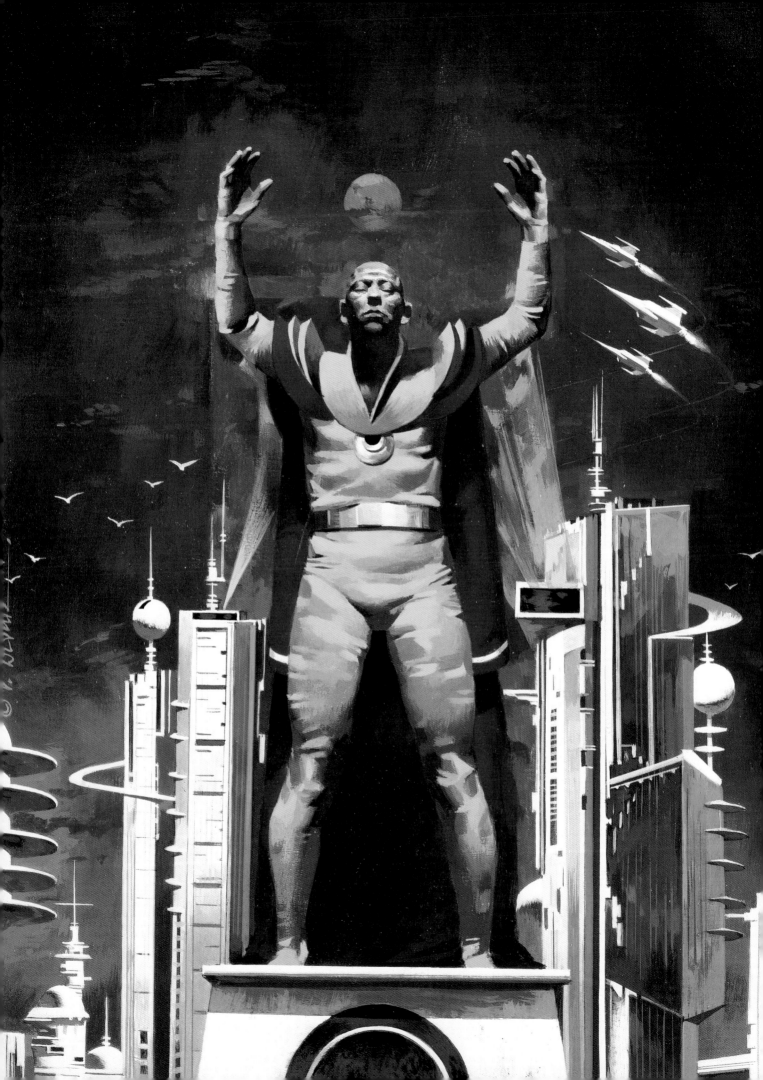

Sci-Fi, Hokum and Barry Who? – The Golden Age of Science Fiction Movies

Fɪʀꜱᴛ, ᴀ ꜰᴇᴡ ᴡᴏʀᴅꜱ ᴀʙᴏᴜᴛ ᴛʜᴇ ᴛɪᴛʟᴇ. 'Sci-fi' is a term that was coined in the early 1950s by Forrest J. Ackerman, the quintessential science-fiction enthusiast and originator and editor of *Famous Monsters of Filmland*, the world's first fan magazine devoted solely to monster movies. Forry recounts that he was driving in his car one day and heard an ad for a stereo sound system on the radio that used the term 'hi-fi', and suddenly it clicked: 'hi-fi', 'sci-fi'. In the 1960s, when science-fiction literature was receiving its first serious recognition from academia, the term became controversial. It was considered vituperative by some. Virtually to a one, writers and academics connected to the genre utterly loathed the American science-fiction film, and thus many started to use the term to differentiate sf movies from sf literature. The written matter was *sf* (no longer standing for just *science* fiction,

it now meant *speculative* fiction), while the movies were merely *sci-fi*.

'Hokum' refers to the kind of nonsensical ideas, crude humour and mawkish sentimentality sometimes associated with things theatrical. The term derives – at least according to Gene Kelly in the 1950 MGM musical *Summer Stock* – from the days when two vaudevillian baggy-pants comics would walk on stage and one would say to the other, 'How come I saw you doing such and such?'

'How come?' 'Hokum.'

More likely it derives from the Latin phrase '*max deus adimax, hax pax*' or, in modern use, 'hocus pocus' for short – a made-up magical conjuration ascribed to medieval alchemists and performers.

This essay will be about science-fiction movies of the 1950s (the pure, lurid core of the film genre) and will touch on the sometimes lunatic science in them and the outrageous campaigns (called 'ballyhoo', but that's another long, *long* story) used to lure patrons to America's movie houses.

Hence the title.

☆ ☆ ☆

When I was a kid in the 1950s I loved the sf movies of the day, and I still do. They were unlike any movies before or since. Though they had much in common with each other, the qualitative differences between them were evident. Some had budgets in the millions of dollars and were produced with intense effort over a period of years; others were cranked out on the cheap over a weekend. Some had Academy Award-winning state-of-the-art special effects, but most used Spartan resources: hastily-made hand puppets, pie-plate flying saucers, stuntmen in crude rubber suits and cave-dwelling creatures assembled

2001: A Space Odyssey
Easton Press, 1993
Pen & ink on scratchboard
Approx. 7in x 5in (18cm x 13cm)

This may sound like utter sacrilege, but I've never much cared for Stanley Kubrick's *2001* (1968). I find it ostentatiously artsy and pretentious and, worst of all, a crashing bore. I recall how Kubrick's collaborator, the profoundly talented Arthur C. Clarke, was cautious when asked what it was like to work with Kubrick. He said *2001* was 'Stanley's film', and at the time I construed this as an attempt to distance himself from it. (Understand that I think both of these gentlemen are brilliant. Kubrick's *Paths of Glory* may very well be one of the best movies ever made, and there simply aren't pages enough in this book for me to extol the many virtues of Sir Arthur – one of the reasons I so enjoy illustrating his work is that it's so visual in its language.) Yet I couldn't refuse to illustrate the special 25th-anniversary edition of the novel when it was offered to me in 1993. I hope I've captured some of the movie's quiet majesty. Indeed, I've recently come to realize that it just might be more enjoyable to watch with the soundtrack turned off – but that's just my opinion.

FACING PAGE
Revolt in 2100
New American Library, 1979
Acrylics on hardboard
8.75in x 14in (22cm x 36cm)

For sf readers of my generation, Robert A. Heinlein will forever be the Dean of Science Fiction Writers. *Revolt in 2100* was one of his classics, and was part of an extensive series of Heinlein books I had the good fortune to illustrate in the late 1970s and early 1980s. This image was inspired not by the story but by a scene in the movie *Things to Come* (1936) in which a mad sculptor appears on a giant screen to deliver an impassioned speech against progress. In this case, progress – for better or worse – being what it is, I decided to use a holographic projection rather than a screen.

out of plastic garbage bags. These humbler efforts were buttressed by equal parts of bravado, naivety, raw imagination and wishful thinking.

Remarkably, more methodical and more expensive efforts didn't always translate into better pictures. Some of the best were not particularly elaborate, suggesting that limitations on occasion challenged the moviemakers to rely on ingenuity and talent rather than capital. When it became clear that there was money to be made from such movies, and an audience of eager youngsters keen to claim them as their own, everyone gave them a try, no matter how ill-suited they were to the task.

Aware that most of them were flawed, I loved them all the same with the undiscriminating passion of a true fan. I'm also certain that I was not alone in my affection for them. If you lived through those days, saw those movies firsthand in a cinema, then you know they were like a funhouse mirror of the anxious times in which we lived. The teenage werewolf rampaging through the high-school gymnasium, the mottled creature skulking in the dark recesses of the lagoon – these were alter egos of the alienated adolescent lurking deep within us. We identified with the Rhedosaurus as it lifted its huge, ancient head from the murky waters of the East River, snacked on a cop, then walked through a skyscraper to avoid a firing squad as it proceeded to lay waste to Lower Manhattan. It was perversely satisfying to see the adult world toppled by the dark forces of the fantastic – by colossal dinosaurs, insects the size of garbage trucks, bikini-clad matrons 50ft (15m) tall and marauding armies from outer space.

If you've come across these vintage sf movies only recently you may have been drawn to them because you find them absurd and at the same time oddly entertaining. It's almost impossible to impress on you, then, how a movie like *The Day the Earth Stood Still* (1951) spoke to my generation about the need to avoid the folly of war and the madness of nuclear annihilation. No matter: so long as you enjoy them, for whatever reasons, then we have a bond. I must confess that I still find myself laughing out loud at the lunacy of *Robot Monster* (1953) or the unbridled imbecility of *The Brain from Planet Arous* (1957). Sometimes I loved them the more the more inept they were. Almost none, no matter how dreadful, weren't worth at least that first hopeful look.

With only a few exceptions the movies of this period weren't like true sf – or at least not like *written* sf – but were instead a curious fusion of crackpot science, pop culture, Cold War hysteria and the trappings of the classic horror film. Great movies like *The Thing from Another World* (1951) and others that it inspired – from *It! The Terror from Beyond Space* (1958) to *Alien* (1979) – more closely resembled the horror film in

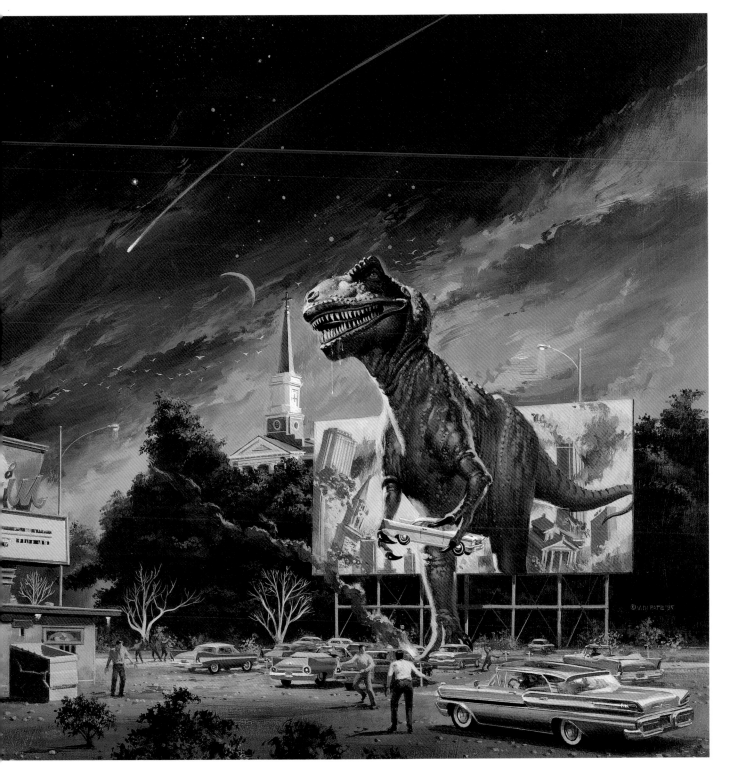

It Came from the Drive-In
DAW, 1995
Acrylics on hardboard
24in x 16in (61cm x 41cm)

The drive-in movie theatre was something of a social institution for the American teenager in the halcyon postwar days. What attracted teens to these outdoor theatres in droves (other than the potential for gymnastic romance in the back seat) were the low-budget, thrill-packed double features of filmmakers like Roger (*She Gods of Shark Reef, Teenage Caveman*) Corman and Bert I. (*Attack of the Puppet People, Amazing Colossal Man*) Gordon. This painting was created for a paperback anthology of short stories in homage to those fondly remembered days. Although it was a valiant effort, the book failed to find an audience. The painting has lived on, however, and has since been reused as a magazine cover, several T-shirt designs, a poster and a print.

mood and appearance than they did the kind of sf that appeared concurrently in print. They enlarged and conciliated the horror-movie formula with scientific exposition in an era in which the supernatural could no longer be taken seriously. The sf stories and the sf movies of the period used science as the catalyst for dramatic conflict; aliens visited the Earth with territorial ambitions, or a new, unproven technology provoked a situation that only the level-headed, resourceful protagonist could fix. In that, the written fictions and the movies were alike. Yet from this common foundation the two genres veered off on wholly different paths.

Personal ambition and the reckless pursuit of knowledge usually corrupted scientists of the 1950s sf film. For violating the laws of Nature and venturing where Man Was Not Meant To Go, they were punished with madness and, in the end, death. Of course, there were mad scientists galore in written fiction, too – in the pulps and as far back as the venerable Dr Frankenstein over a century before. But by sf literature's Golden Age – roughly from the late 1930s to the mid-1950s – the role of the scientist was seen in a more deferential light.

The motives for this negative view of scientists in the broader, movie culture, particularly in the early days of the Atomic Age, were obvious. Scientists, with their obtuse language and aloof analytical minds, were very different from the rest of us. It was easy to imagine them as cold and remote, given to heartless acts, insane aspirations and flights of madness. It was easy to conceive that their complicated breed might have a willingness to place the quest for knowledge above concerns of human need, for, after all, they had given us a quick, sure means to eradicate ourselves.

Science itself was also a victim of these movies. Frequently what science was in them made little sense – even in an otherwise good film like *Them!* (1954) – and we were continually warned that there were things We Were Not Meant To Know, or that scientific advancement could only bring about our ultimate destruction.

☆ ☆ ☆

The sf-movie cycle began in 1950 with the release of Kurt Newman's *Rocketship X-M* and George Pal's *Destination Moon*. Certainly there had been earlier efforts – like Méliès's *A Trip to the Moon* (1902), Lang's *Metropolis* (1926), Wells's and Menzies's *Things To Come* (1936), and a few sf/horror hybrids like *The Invisible Ray* (1936), *Dr Cyclops* (1940) and of course *Frankenstein* (1931). But these two mid-century interplanetary travelogues started the whirlwind that would grow into the sf film's Golden Age.

I saw my first sf movie, *Rocketship X-M*, in 1950 at the age of four. On my way out of the theatre the box-office attendant gave me a cardboard punch-out of the *R X-M* printed in blue and red ink on a thin sheet of white chipboard. I remember playing with it constantly until every trace of ink had rubbed off on my hands. By 1951, with the release of *The Man from Planet X*, *The Thing from Another World* and *The Day the Earth Stood Still*, I was hooked.

I didn't know then that there were fundamental differences between sf on the silver screen and sf on the printed page. The books I bought in those long-ago days were written in a language too obtuse for me to understand. The images on the covers were the principal attraction, and I would sit for hours frustrated in my effort to read them, trying to imagine, based on the pictures alone, what the stories were like inside. I had no idea that this process was conditioning me for my role in later life. Truthfully, this early exposure to the genre was, in a way, terrifying for me. Hostile aliens, lumbering robots, atomic mutations and rampaging dinosaurs filled my wakeful thoughts and haunted my nightly dreams.

In 1951, then, before the conventions of this new film genre had even taken shape, a dichotomy was formed. On the one hand there were *The Man from Planet X* and *The Thing from Another World* – films largely built on the well established foundations of the traditional horror movie – and on the other there were *The Day the Earth Stood Still* and *Five*, films which dared to deliver timely philosophic messages using sf as a vehicle. Both *The Thing* and *The Day the Earth Stood Still* were based on pre-existing works of fiction. Both radically departed from them.

☆ ☆ ☆

I've already spoken at length in this book about *The Thing* and its source story, 'Who Goes There?' (see page 15). *The Day the Earth Stood Still* is so exemplary in every respect that it, too, is worth some discussion.

Almost certainly one of the greatest sf

movies ever made, *The Day the Earth Stood Still* is based on a Harry Bates story, 'Farewell to the Master', which appeared in the October 1940 issue of *Astounding Science Fiction*. Bates was a predecessor of John W. Campbell Jr – the author of 'Who Goes There?' – in the editorship of *Astounding*, back in the days when it was known by the lurid title *Astounding Stories of Super-Science*. His original story had been about a space/time traveller named Klaatu and his robot companion, Gnut, who journey to Earth from the human future. As in the film, Klaatu is shot shortly after the arrival of his vehicle on the mall of the Smithsonian Institution in Washington DC. Also as in the movie, the robot tries to revive (or, actually, to duplicate) his human companion. A photographer, Cliff Sutherland, takes daily pictures of the seemingly immobile robot and realizes its secret nocturnal activities only when he compares his negatives, discovering that Gnut's feet are never in exactly the same place two days running. Sutherland follows the robot to a zoo one evening. Gnut abducts an ape and, after placing the animal in a duplicating machine aboard his ship, produces a successful replica of the fallen Klaatu. Before the travellers depart, Sutherland tells Gnut to give his (Sutherland's) farewells to his master, to which the robot replies, 'You misunderstand. I am the master.'

The movie version, by contrast, tells the tale of the visiting *alien*, Klaatu, and his lumbering robot, *Gort*, who have come to Earth to deliver an ultimatum to humankind that it must cease its warlike activities or risk extermination for the good of the populated worlds of the Galaxy. These worlds have achieved a lasting peace by creating a race of robots that have absolute authority over them in matters of dispute; the robots are seemingly all-powerful, able to destroy entire worlds if that is necessary to eliminate aggression.

Michael Rennie portrayed the urbane Klaatu in his career-defining performance. The exceptional supporting cast included Patricia Neal, as war widow Helen Benson, Sam Jaffe as the Einstein-like Dr Barnhardt, and Billy Gray as Helen's young son Bobbie. The movie's director, Robert Wise, started out as a film editor at RKO (he worked on the 1941 Orson Welles classic *Citizen Kane*), then got his directing start with the Val Lewton production unit at RKO with movies like *The Curse of the Cat People* (1944 –

co-directed with Gunther von Fritsch) and *The Body Snatcher* (1945; a horror movie based on the Burke and Hare case). Among his many accolades are Best Director Academy Awards for *West Side Story* (1961) and *The Sound of Music* (1965).

The message of Harry Bates's original story is clearly a warning to us about what might happen if we allow our technology to rage out of control. The same could be said of the film, in a sense. Its focus, however, is not on reining in technology, per se, but rather on our inability to get along with each other in a time when our technology has advanced sufficiently to bring about our own extinction.

What matters most in considering the importance of this film is that it was among the first to use sf as a vehicle for delivering a message of higher purpose. Although it differed substantively from its literary source, it was fairly close to the kinds of stories that readers were encountering in the magazines. More importantly, and despite some effective and terrifying moments, it was not in any significant way a horror movie – and nor did it *look* like one: Lyle Wheeler's and Addison Hehr's set designs and the design of the robot were at the pinnacle of 1950s Modernism.

It's difficult to know why sf movies took a decided turn toward the conventions of horror in the next few years as the genre developed its distinctive formulae. Even so, there were subtle differences between the 'monsters' of the horror film and the 'creatures' of the sf film. In her marvellous book *The Limits of Infinity: The American Science Fiction Film* (1980), Vivian C. Sobchack points out that the monsters of the typical horror film represent the corruption of the human soul – that they are anthropomorphic in appearance and are presented as distorted versions of ourselves – whereas in the standard sf film the creatures are totally alien and remote from us in both appearance and in our inability to empathize with them. Even in this there were exceptions, the gill man in *Creature from the Black Lagoon* (1954) being among the most notable.

Perhaps the trend toward the convention of the horror film came about because that tradition required a less extensive knowledge of science. Alternatively, perhaps when the moviemakers of the day analysed earlier films in

Eyes with Speeding Car
Analog, 1971
Pen & ink on scratchboard
5.5in x 4.25in (14cm x 11cm)

This small spot drawing was done for one of W. MacFarlane's *Ravenshaw* stories, 'Heart's Desire and Other Simple Wants', which ran in the April 1971 issue of *Analog*. As a drawing for an sf magazine this looks, I think, a bit too much like it was meant for a horror story, but somehow it passed muster. Confusion of genres was something about which John W. Campbell was rather a stickler, perhaps from the experience of having to differentiate the contents of *Astounding* from its lighter, short-lived companion *Unknown*.

FACING PAGE

Creature from the Black Lagoon

FilmFax, 1999
Acrylic on hardboard
Approx. 14in x 18in (36cm x 41cm)

The Gill Man, as he is sometimes known, is *the* emblematic monster of the 1950s Golden Age of sf movies. Not only was he exquisitely designed and executed by the make-up department at Universal Studios, his first two outings were filmed in dazzling 3D. 3D was a process of stereo-photography which gave the illusion of depth, and for anyone who saw these films first-hand the effect was quite remarkable (subsequent attempts to revive 3D using an anaglyphic process are only a pale suggestion of the real thing). The Creature's first appearance came in 1954, and he instantly found favour with American teenagers. Many of us identified with his feelings of alienation and felt the brooding pain of his angst. I always thought of him as a latex version of James Dean – deep, dynamic, distant and disconsolate. This painting was done for a special issue of *FilmFax* in homage to the Big Green Guy, and was almost destroyed by the United Parcel Service on its way back to me (they found a way of folding the art, which had been painted on Masonite!). Happily, the restored work now hangs in the much-celebrated collection of my dear friend Bob Burns.

the hope of emulating their success, a certain distillation occurred. There had been a long and effective tradition of horror in the cinema, dating back at least to *Das Kabinett des Dr Caligari* (1920) and even before – a tradition with a particular look and style that could be modified for contemporary audiences by merely giving the supernatural being a scientific rationale and a sleeker, nonhuman look. Futuristic sets, to the limited extent they were used, were easy and inexpensive to create because of their streamlined simplicity. The set for the flying-saucer interiors in *Invaders from Mars* (1953) springs immediately to mind as an example: the walls were fashioned from sheets of green plastic roofing material suspended vertically and backlit above a cramped soundstage only 28ft (8.5m) long. It really wasn't until the 1970s and 1980s, with movies like *Alien* and *Batman* (1989) and the inflated budgets that they commanded, that sf films took on a more baroque and intricate look.

In all likelihood it was a combination of various factors that motivated filmmakers to make the movies they did, in the ways that they did them. The fact that moviegoers, and particularly large groups of teenagers, flocked to theatres at a time when other kinds of theatrical films were being seriously challenged by television, proved the power of sf to attract an audience.

☆ ☆ ☆

The year 1952 produced only a handful of sf films, none particularly significant, but the next year the floodgates opened wide, and the number of movies released in this genre escalated throughout the remainder of the 1950s. Four of the twenty or so films with some sf content released theatrically in 1953 are notable: *Invaders from Mars*, *The Beast from 20,000 Fathoms*, *It Came from Outer Space* and *The War of the Worlds*.

Ray Harryhausen's stop-motion animated *The Beast from 20,000 Fathoms* was the first giant-monster movie of the decade and ushered in a menagerie of radioactive creatures of colossal size, from gigantic saurians (*Godzilla, King of the Monsters*, 1954/1956; *The Giant Behemoth*, 1958) to enlarged insects (*Them!* 1954; *Tarantula*, 1955) and mutated humans (*The Amazing Colossal Man*, 1957; *Attack of the 50 Ft. Woman*, 1958). *The Beast from 20,000 Fathoms* introduced the name of fantasy author Ray

Bradbury to sf moviegoers, the title of the movie having been taken from one of his *The Saturday Evening Post* short stories. Not just the title – the movie also incorporated and expanded on a scene from the story in which a prehistoric sauropod attacks a lighthouse.

Although produced independently, the movie was quickly snapped up by Warner Bros. for distribution. A saturation advertising campaign – one of the very first for an sf film – was initiated. Trailers ran constantly on TV; the lobbies of theatres displayed animated standees in which the Beast's red eye lit up and its toothy jaws swung open; sound trucks with sandwich boards of the poster art scoured neighbourhoods in search of patrons (mainly kids home from school on a Saturday afternoon); large red reptilian footprints, painted on the sidewalks for blocks around, led the way to local movie houses where *The Beast* was playing.

The plotline of *The Beast* is rather linear. A prehistoric creature is awakened from its sleep of centuries when an atomic bomb is detonated at the North Pole. The Beast makes its way to New York City and, after trashing a few recognizable landmarks, is finally destroyed by a powerful new radioactive device (an isotope fired from the muzzle of a rifle by marksman Lee Van Cleef, who is perched atop the Cyclone roller-coaster at Brooklyn's Coney Island). Change the locale to the Pacific Ocean, the city to Tokyo, the isotope to an 'oxygen destroyer', and the monster from a stop-motion model to a man in a rubber suit and you have *Godzilla*. Continue to alter the location and a few incidental plot points, but retain all the other main details, and you have *The Giant Behemoth*, *Gorgo* (1961) and the essence of almost every other prehistoric reptile that ever shambled across the silver screen; *Jurassic Park* (1993) and its 1997 sequel *The Lost World* were exceptions in that their dinosaurs were reconstituted from DNA, a molecule utterly unknown to the science of the 1950s. *The Beast* stars Paul Christian as physicist Tom Nesbitt, Cecil Kellaway as palaeontologist Thurgood Elson (in the film's only exceptional performance) and Paula Raymond as Elson's assistant, Lee Hunter. The direction was provided by former movie art director Eugene Lourie, who would later helm both *The Giant Behemoth* and *Gorgo*.

☆ ☆ ☆

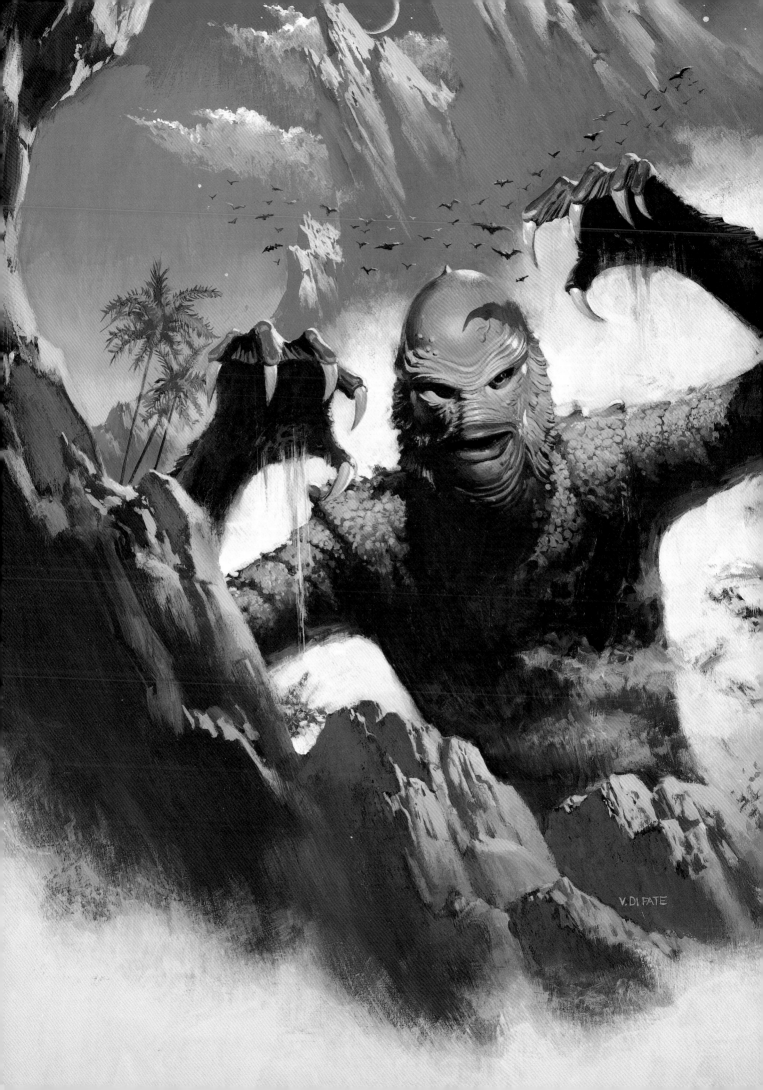

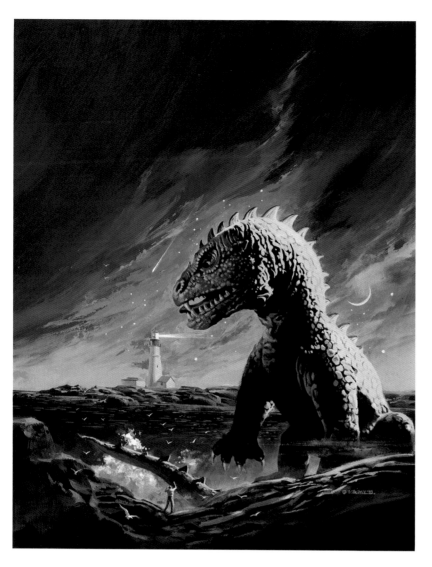

The Beast from 20,000 Fathoms

San Francisco Examiner, 1993
Acrylics on hardboard
Approx. 12in x 16in (30cm x 41cm)

The Rhedosaurus was the first screen 'dinosaur' I fell in love with, and was almost certainly the inspiration for Toho's 1954 movie *Godzilla, King of the Monsters*; even the plots are essentially the same. In the 1953 Ray Harryhausen film, the Beast laid waste to lower Manhattan after being liberated from Arctic ice by an atomic bomb. This landmark effort gave birth to the glorious 'aesthetics of destruction', a term that film historians now use to characterize these mid-century excursions into large-scale violence. The painting was created for an article written by Bob Stephens and myself, 'It Came from '53', an essay in homage to the sf cinema's finest year.

Ray Bradbury's name resurfaced in early June of the same year, 1953, with the release of Universal-International's first 3D feature, *It Came from Outer Space*. Bradbury's poetic screen treatment was the basis of an effective script by Harry Essex. *It Came from Outer Space* introduced a recurrent archetype to sf movies, the resourceful, sympathetic scientist (Richard Carlson as neophyte astronomer John Putnam) and was the first genre film to be directed by Jack Arnold. Arnold would go on to helm some landmark features, including the iconic *Creature from the Black Lagoon* (1954) and the existential *The Incredible Shrinking Man* (1957).

Both *It Came from Outer Space* and *Invaders from Mars*, released the previous month, dealt with what was to become a predominant theme in 1950s cinematic sf, that of alien infiltration. In *It Came from Outer Space* the aliens didn't take possession of human beings but instead transformed themselves to look like humans, after

first abducting and detaining them in an abandoned mine. Against the real-life backdrop of the Cold War and the widespread apprehension that Communist sympathizers were infiltrating the government and stealing crucial atomic secrets, these films tapped into the nation's gravest fears. Later examples of this fright-filled subgenre would include the best of all the alien infiltration movies, Don Siegel's *Invasion of the Body Snatchers* (1956).

Invaders from Mars was shot in colour and directed by William Cameron Menzies, an Academy Award-winning art director. Menzies trained to be an illustrator and studied in Leonia, New Jersey, with the noted illustrator and painter Harvey Dunn. Dunn was the mentor of such illustration notables as Dean Cornwell, Saul Tepper, Mead Schaeffer, Harold von Schmidt and Anton Otto Fisher, and was himself a student of the legendary Howard Pyle. Menzies pioneered many techniques that are now in common use in Western cinema, and he earned the first Academy Award given for art direction for two films, *The Dove* and *Tempest*, both venerated motion pictures of the silent era. In a career that spanned more than three decades he designed many films, including the 1939 MGM classic *Gone With the Wind* and, without proper credit, the 1940 Alexander Korda *The Thief of Baghdad* (he's listed in the credits only as one of several executive producers); remarkably, Menzies had also worked on the silent 1924 Douglas Fairbanks version of *Thief*. Beginning in the 1930s he directed a small but important group of movies, many of which had sf or fantasy themes; these included the movie serial *Chandu the Magician* (1932), the feature *Things To Come* (1936) and one of the last of the mid-century 3D features, *The Maze* (1953). He died of complications from lung cancer in 1956. Menzies is today acknowledged as one of the formative influences on the look of modern cinema. And it was really the *look* of *Invaders from Mars*, even more than its theme of alien possession, that resonated so acutely with filmgoers.

The movie begins with young David Maclean (Jimmy Hunt) witnessing the landing of a flying saucer in a sandpit behind his home. His parents and, soon after, other trusted members of the community are systematically abducted and implanted with small radio devices at the base of the skull. The devices

allow the Martians to exercise complete control over the actions of their subjects. Secreted in an underground labyrinth of tunnels and passageways, the Martians plot to sabotage an atomic rocket project for which David's father is a chief engineer. The Martian leader is a golden, disembodied head in a transparent globe. The creature – humankind evolved to its ultimate state – directs the actions of its minions by means of telepathy. Its slaves are green, bulbous-eyed, 8ft (2.4m) synthetic humanoids (actually, very tall actors in green velour suits with the zippers clearly visible) who, at one point, place a woman on an examining table to be implanted with one of the control devices. The devices, miniaturized variable oscillators that transmit electrical impulses to the brain, are delivered by means of an X-shaped needle. At the film's conclusion we discover that the nightmarish events of the story are only a dream – that is, until David awakens to see the flying saucer land again. For the version released in the UK the idea of the story being a dream was omitted.

Having seen the film in May 1953, at the age of seven, I spent the following months all but convinced that my parents had been taken over. More terrifying than even this sinister suspicion were my recurrent nightmares in which I found myself on an examining table inside an alien spacecraft surrounded by big-eyed, humanoid extraterrestrials. Dr Kenneth Ring, a professor of psychology at the University of Connecticut, has cited *Invaders from Mars* – in his book *The Omega Project: Near-Death Experiences, UFO Encounters, and Mind at Large* (1992) – as a likely source of reported alien-abduction experiences. What is consistently reported in such cases is that the subject is taken inside a UFO by large-eyed humanoids, placed on a table, exposed to a physical examination and implanted with a small metallic device.

☆ ☆ ☆

In late October 1953 producer George Pal's movie adaptation of H.G. Wells's famous novel *The War of the Worlds* opened in theatres all across America. It, too, is among the best sf films ever made – a visually stunning orgy of colour, sound, action and Oscar-winning special effects. The original novel takes place in Victorian England, in and about the city of London. George Pal chose to update the story

to a (then) contemporary setting and to move the action to Southern California. Pal had previously produced the features *The Great Rupert* (1950), *Destination Moon* (1950) and *When Worlds Collide* (1951). In years to follow he would be a frequent contributor to the cinema of the fantastic with films like *The Naked Jungle* (1954; based on the famous Carl Stephenson story 'Leiningin Versus the Ants'), *The Conquest of Space* (1955; adapted from a nonfiction book by Willy Ley and Chesley Bonestell), *The Time Machine* (1960; another rendition of an H.G. Wells novel) and *The Wonderful World of the Brothers Grimm* (1962; the first full-length Cinerama feature to actually have a plot).

I don't imagine anyone reading this book would be unfamiliar with Wells's story or with what stands, after nearly fifty years, as the premiere motion picture of its kind. The actors are adept and workmanlike, but the true appeal of the movie lies in its staging of the invasion itself. The Martian war machines are elegantly lethal in appearance, with a body shaped like a manta ray and a head and neck resembling those of a hooded cobra. In keeping with the flying-saucer craze of the time, the machines, which walk on jointed legs in the novel, are in the movie suspended from the ground by invisible magnetic beams. The cobra head emits a ray that instantaneously incinerates its target – the wingtips of the machines fire a bright green beam (referred to in the on-screen dialogue as a 'skeleton beam') that tears matter apart at the subatomic level, as shown in vibrant Technicolor when tanks, trucks, cannons and personnel are zapped and turn a sequence of colours (green to red to yellow, depending on the target's density) before disappearing from view. This is illustrated dramatically (and rather graphically for its time) when actor Vernon Rich, as Colonel Heffner, gets blasted and dissolves into green vapour after we are first treated to an X-ray view of his skeleton. The blazing finale, which depicts the Martian siege of Los Angeles, remained unsurpassed in the annals of cinematic mass destruction until the release of such multi-million dollar extravaganzas as *Independence Day* (1996) and *Mars Attacks* (1996). Despite what state-of-the-art effects and other virtues these later films possess, none has seriously challenged the status of *The War of the Worlds* as the screen's definitive treatment of the alien-invasion theme.

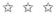

The 1984 World's Best SF

DAW, 1984
Acrylics on hardboard
14.5in x 23in (37cm x 58cm)

Ever since being scared out of my wits at age five by the vision of Gort, the omnipotent automaton of the classic sf movie *The Day the Earth Stood Still* (1951), I've held a special fondness for robots. The cover of this anthology, edited by Donald A. Wollheim, one of the pioneer editors of modern sf, offered an opportunity to let my imagination take flight. Admittedly, the multi-armed machine that assumes centre stage bears an uncanny resemblance to a vacuum cleaner, but there's little doubt in my mind that an early fear of loud noises was, in some subliminal way, a contributing factor.

The 1984 World's Best SF

Sketch, 1984
Acrylics on hardboard
5.75in x 8.5in (15cm x 22cm)

The format for the paperback edition of this book required that all the authors included in the anthology be listed in a column on the right side of the painting (note the hastily brushed in lines to suggest the position of the type). It always bothered me, however, that there was a large empty space in the middle of the scene, so when I got the art back I added a dust cloud and a few soaring spaceships to complete the painting.

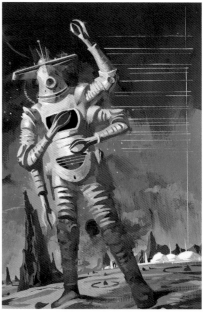

There were other noteworthy movies in 1953: Ivan Tors's *The Magnetic Monster*, starring the ubiquitous Richard Carlson; Curt Siodmak's *Donovan's Brain*, with Lew Ayres and Nancy Davis (Reagan); and – the guiltiest pleasures of all – *Robot Monster* and *Abbott and Costello Go to Mars*.

Then came 1954, another vintage year for sf, with treasures like *Creature from the Black Lagoon* (again starring Carlson), *Them!* and Walt Disney's lavish production of Jules Verne's *20,000 Leagues Under the Sea*.

Creature from the Black Lagoon was Jack Arnold's second outing in the genre and perhaps the film most associated with the fascinating but short-lived 3D process, a stereoscopic technique whereby objects appeared to have depth and to move right off the screen. In the war against television, 3D seemed to be cinema's ultimate weapon, but complaints of eye-strain and other problems brought about its quick demise.

The Creature represented one of the most exquisitely designed fantasy costumes of the 1950s, the work of the Universal make-up department under the supervision of Bud Westmore. The movie was immensely popular, especially with teenagers, and warranted two sequels, *Revenge of the Creature* (1955; again directed by Arnold and photographed in 3D – the last feature-length 3D effort of the decade) and *The Creature Walks Among Us* (1956; directed by John Sherwood).

This year was also the one that saw the release of the dismal *The Monster from the Ocean Floor*, the first genre movie produced by Roger Corman. Although his production budgets would remain small (*Monster* reputedly cost less than $20,000), Corman's later excursions into sf would prove substantially more interesting;

they include *The Day the World Ended* (1955), *It Conquered the World* (1956), *Attack of the Crab Monsters* (1957), *Not of This Earth* (1957), *War of the Satellites* (1958), *Teenage Cavemen* (aka *Prehistoric World*; 1958) and *The Wasp Woman* (1959).

The year 1955 brought the underappreciated Technicolor space epic *This Island Earth*, based on a novel by Raymond F. Jones that had been serialized in *Thrilling Wonder Stories*. Also of interest were: George Pal's last film for Paramount, *The Conquest of Space*; another Harryhausen giant-monster picture, this time with a colossal octopus, *It Came from Beneath the Sea* (his first of many collaborations with producer Charles H. Schneer); and Jack Arnold's third sf venture, *Tarantula*.

Then 1956 gave us *Forbidden Planet* (MGM), perhaps the one movie most sf fans agree is a good one, and the nightmarish *Invasion of the Body Snatchers*.

Forbidden Planet, although not based on an sf story (Irving Block, the project's originator, attributed the plot to Shakespeare's *The Tempest*), is certainly the closest any of these movies ever came to capturing the spirit of written sf as it existed in the 1950s. At the core of the plot is a concept grounded in science, albeit the 'soft' science of psychology: monsters from the subconscious mind, after wiping out an ancient race centuries before, return to stalk the crew of an interplanetary cruiser on a rescue mission. When the project was initiated in 1954, MGM had never released an sf movie, instead having built a reputation through the 1930s, 1940s and 1950s for elaborately produced musicals; without any preconceived notions or formulaic ideas, the studio brought to *Forbidden Planet* a scope and grandeur light years ahead of anything else being made at the time.

Allied Artists' *Invasion of the Body Snatchers*, produced on a far leaner budget, is one of the most atmospheric and effective sf thrillers ever produced, and it has spawned two remakes, *Invasion of the Body Snatchers* (1978) and *Body Snatchers* (1993). It was certainly also the inspiration for later alien-infiltration movies, such as Michael Laughlin's *Strange Invaders* (1983), even though the theme had been well delineated in earlier films by the time *Invasion of the Body Snatchers* made its way into theatres. The year 1956 also saw the importation and dubbing (with added American footage) of the 1954 Japanese film, *Gojira*, better known in the West as *Godzilla, King of the Monsters*. Japanese monster movies were ubiquitous in theatres and drive-ins worldwide through the late 1950s and into the mid-1960s, as US- and UK-made sf movies all but disappeared. In 1956 Columbia also released a sterling creature-feature twin bill, teaming Harryhausen's *Earth Versus the Flying Saucers* with *The Werewolf*, both directed by Fred F. Sears and both sf, despite the title of the latter. Another import, *The Creeping Unknown* (aka *The Quatermass Xperiment*; 1955), this time from the UK's Hammer Studios, flickered on movie screens all across the USA and created a sensation when teamed on a double bill with *The Black Sleep*, a picture that fused sf with horror. Although Hammer had given us two earlier excursions into the genre, *The Four-Sided Triangle* (1952) and *Spaceways* (1953), *The Creeping Unknown*, based on Nigel Kneale's BBC teleplay for *The Quatermass Experiment* (1953), gave the first clear signal that Hammer had something fresh and interesting to offer. What was new was a willingness to show what so many earlier sf and even horror films had shied away from: explicit gore.

The on-screen gore in *The Creeping Unknown* is pretty tame by modern standards, but by 1957, with the release of the sensational *The Curse of Frankenstein* – in bleeding colour – Hammer had quickly become the new home of motion-picture horror. In so doing it accomplished what Universal had done, less graphically and without the benefit of colour, twenty-six years earlier with the release of *Dracula* (1931) and *Frankenstein* (1931). Hammer's aggressive plan to capture the market included remakes of many of the Universal horror classics; in the last years of the decade came *The Horror of Dracula* (1958), *The Revenge of Frankenstein* (1958), *The Hound of the Baskervilles* (1959) and *The Mummy* (1959). There were a few 'purer' sf films on the Hammer roster, including *Quatermass II* (aka *Enemy from Space*; 1957; a sequel to *The Creeping Unknown*), *X – The Unknown* (1957) and *The Abominable Snowman of the Himalayas* (aka *The Abominable Snowman*; 1957; based on another Nigel Kneale BBC teleplay, entitled *The Creature*). There was also a Hammer remake of a non-Universal horror film, *The Man who Could Cheat Death* (1959), based on the 1944 Paramount feature *The Man in Half Moon Street*.

FACING PAGE
The War of the Worlds
Outré, 2001
Acrylics on hardboard
18.75in x 24in (48cm x 61cm)

Although there are many sf films of the 1950s of which I'm fond, George Pal's 1953 Technicolor rendition of H.G. Wells's classic novel holds a very special place in my heart. After half a century it still stands as the definitive movie of alien invasion, despite the passage of time and innumerable improvements in special-effects technology. Art director Albert Nozaki's sleek designs of the Martian war machines is the key, I think, and this painting is actually something of a homage to his own photomontage painting for the 1952 Pocket Books pre-release paperback tie-in. It was salvaged from an earlier assignment I did for a cellular phone company that parodied the film in an ad campaign entitled *War of the Wireless*. It followed the rare style 'B' half-sheet art but, instead of the Los Angeles City Hall building in the background, the landscape was composed of flaming wireless telephones.

Hammer continued to be a pre-eminent producer of fantastic films – mostly horror with some sf thrown in – throughout the 1960s, but gradually lost ground through the 1970s until 1978, when the studio was finally disbanded. Competition from other European-based independents, like Eros and Amicus, who had learned to copy the style almost flawlessly, and the entry into the horror field of American International Pictures with Roger Corman's *The House of Usher* (1960) – the first of many Edgar Allen Poe-based films done by AIP and others – contributed to Hammer's demise.

☆ ☆ ☆

A few other trends in 1957 aside from Hammer's sudden, successful shift towards horror would impact big-screen sf. AIP was the first studio to grasp the fact that teenagers made up the largest group of patrons flocking to see such films. A large part of AIP's distribution had been not to the big theatre chains, where the major studios were entrenched, but rather to small independents and to drive-ins. During the mid- to late 1950s the drive-in became the ritual meeting ground for teens to congregate, and AIP set out to lure them, teaming films in double bills that were guaranteed kid magnets. The double-bill releases of *The Day the World Ended* and *The Phantom from 10,000 Leagues* (January 1956, when AIP was still known as the American Releasing Corp.) and, later that year, of *It Conquered the World* and *The She Creature* were examples of this marketing strategy.

In June 1957 AIP outdid itself by releasing the quintessential teen-sf monster-movie pairing: *I Was a Teenage Werewolf* and *Invasion of the Saucer Men*. Despite the title of the first, these were both decidedly sf movies. More importantly, teenagers played a major role in the plots of both. I was eleven when I plunked down my thirty-five cents at the box office of the local movie house to see this twin fright-bill. *I Was a Teenage Werewolf* is probably best remembered today because of its flamboyant title and the fact that it featured a young Michael Landon in his first starring role – he plays the angst-ridden Tony Rivers, a troubled high-school student who is referred to psychiatrist Alfred Brandon (Whit Bissell). Brandon has his own ideas about how to treat Tony and, with the combined use of injections and hypnosis, regresses the boy to a primitive state in which he assumes the characteristics of a wolf. Brandon, the biggest screen crackpot since George Zucco attempted to save humanity from itself by creating a werewolf army in *The Mad Monster* (1942), has decided the only way to avoid nuclear Armageddon is to reduce humans to their most elemental form.

I was nearly a teenager myself at the time, and, when Tony was shocked into an involuntary transformation by the ringing of a school bell, it was like watching myself sprout fangs and storm out of the school gymnasium on a rampage. That film spoke volumes to me about my repressed anger and intense feelings of aggression and alienation.

Invasion of the Saucer Men, although irresistibly appealing to those of us with 1950s-sf-movie tunnel vision, is in truth just a fairly guileless comedy. It deals with the landing of a flying saucer in a lovers' lane and with a group of teenagers who must take matters into their own hands when authorities refuse to believe their story. Leading the teenagers are Johnny Carter (Steve Terrell) and Joan Hayden (Gloria Castillo), youngsters who get sidetracked in their effort to elope when they run down a little green saucer man with their car. The saucer men are, however, the real stars of the picture, and are the handiwork of the brilliant Paul Blaisdell, a former illustrator turned low-budget monster-maker. He created the outlandish, cabbage-headed aliens – which are actually pink, not green, as stated in the on-screen dialogue – out of moulded foam rubber. Among the menagerie of beasts the resourceful Blaisdell gave us were the fearsome hand-puppet creature from *The Beast with a Million Eyes* (1956), the awesome Venusian cucumber from *It Conquered the World* (1956) and the super-scary walking tree, the Tabanga, that appeared in *From Hell It Came* (1957).

☆ ☆ ☆

In addition to this move to capture the teenage audience, the third and perhaps most decisive thing to happen to fantastic cinema in that bumper year of 1957 came from the small rather than the big screen: the leasing of the Universal horror film library to ABC-TV. I will never forget that glorious evening in the early Fall when *Shock Theatre* premiered on New York's Channel 7 with an 11:15pm airing of the 1931 *Dracula*, starring Bela Lugosi. The movies ran on Friday night and were repeated on the Saturday.

The Encyclopedia of Monsters

Facts On File, 1989
Acrylics on hardboard
Approx. 16in x 20in (41cm x 51cm)

My good friend Jeff Rovin is something of an expert on the fields of fantastic litera- ture and film and has written a series of important encyclo- pedic works on these subjects for Facts On File, one of America's prolific producers of reference books. The chal- lenge of this book cover was to create a 'family portrait' of familiar monsters without violating copyright in any of the trademark-protected characters of the major movie studios. We weren't fooling anyone, of course – but that was precisely the point!

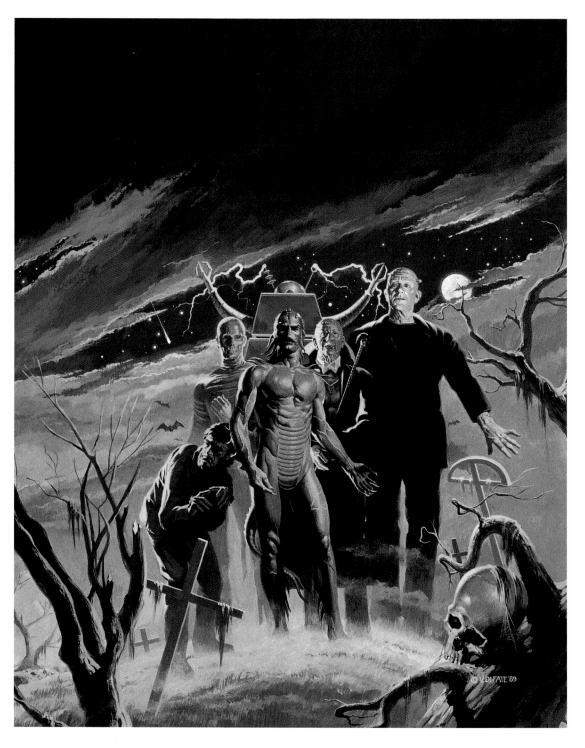

So it was that I was exposed to the 'classics' close up and personal, the armchair pulled to within inches of the screen, *twice over* every weekend for two years, until the supply was depleted. In later years these movies would be rerun endlessly, and other shows, like *Nightmare!*, *Chiller Theatre* and *Creature Features*, continued with the second-, third- and fourth- tier films until they were all exhausted.

With the entrenchment of colour TV in the late 1960s, few of these horror shows, with their old black-and-white movies, could muster a suf- ficient audience to stay on the air; for a time they became an endangered species.

While the number of sf and horror films being released continued to escalate through the closing years of the 1950s, interest in them began to wane. Perhaps it was a simple matter of overkill, although I think there was far more to the story of their demise than merely that. As audiences declined, production financing diminished from low-budget to no-budget.

Auteurs like Edward D. Wood Jr (*Bride of the Monster*, 1956; *Plan 9 from Outer Space*, 1959) and Sid Pink (*The Angry Red Planet*, 1960; *Journey to the Seventh Planet*, 1961) got their day in the sun and proved for good and all that they were ultimately inadequate to the task.

A bright spot in the gloom, as this era began to slip away from those of us who loved these movies dearly, was the inaugural publication of the magazine *Famous Monsters of Filmland* in February 1958. It was soon followed by a rash of like-minded magazines: *World Famous Creatures*, *Spacemen*, *Shriek*, *The Castle of Frankenstein*, *Monster World*, *Fantastic Monsters of the Films*, *Mad Monsters*, *Chilling Monster Tales*, *Modern Monsters*, *Monster Madness*, *Monster Mania*, *Monster Parade*, *Monster Land*, *For Monsters Only* . . . and the list goes on.

As fortunes declined, some moviemakers showed a flamboyant energy and a flair for invention in their desperation to fill theatre seats. The most notable of these shameless hucksters was William Castle, whose ludicrous gimmicks and barefaced ballyhoo are still the talk of Hollywood nearly five decades later. Castle's *Macabre* (1958) offered $1,000 insurance policies in the lobby for patrons who died of fright. *House on Haunted Hill* (1959) featured 'Emergo', a gimmick in which a rubber skeleton rode at the appointed moment down a wire from the projection booth to the stage. *The Tingler* (1959) offered 'Percepto', whereby patrons in selected seats got a low-voltage electrical shock. *13 Ghosts* (1960) was filmed in 'Illusion-O' – by donning special glasses, audiences could choose whether or not to see a lame entourage of household ghosts. *Homicidal* (1961), a shameless gender-bending knock-off of Hitchcock's *Psycho*, offered a 'Shock Break' as the film approached its fearsome conclusion. And so it went. Although this level of hyperactive showmanship was wildly popular for a time, the carcass of fantastic cinema was, by the end of the 1950s, lying in a pool of its own blood, its pulse irrevocably diminishing.

☆ ☆ ☆

So who or what killed the spirit of science fiction in the movies? Over-saturation? Certainly. The move towards horror? Possibly. Had we, the prime audience for these films, merely grown up and grown out of love with them? Well, never me personally, but as the years went by I found fewer and fewer of my peers who shared an interest in them. Some say that Sputnik killed science fiction; that when we moved into the Space Age the world of fantasy could no longer compete with the marvels of reality. To me that hardly makes much sense at all – but maybe that's just me. I do know that, as we moved into the 1960s, the world took a darker and uglier turn. The Cold War tottered on the brink of turning hot with the downing of Francis Gary Powers's U-2 Spy Plane over the USSR, the failed Bay of Pigs invasion and the Cuban Missile Crisis. The chaos that followed – the Kennedy assassination, the escalation of the US presence in Vietnam, the Vietnam War, the race riots at home – all changed who we were, how we looked at each other, and how we viewed the world. With the graphic reportage of the war each night on the evening news, for a time I found going to horror movies distasteful. And, in truth, as these films became progressively more graphic and more violent, my appetite for them never really returned.

☆ ☆ ☆

Ah, but at the sf end of the movie spectrum, these films remain still vivid and meaningful to me. In the late 1960s, as my career took off and my income grew, I began to collect these cherished features in 16mm. It was heaven to sit in the dark and watch them, especially when events in the outside world filled me with anger, or disappointment, or sorrow. They would take me to places cool and distant, places illuminated by unfamiliar suns, yet filled with hope and wonder. They would, with their outrageous plots and high adventure, clear my mind, give me focus and new perspective.

Many in my generation look at these films as foolish and without merit, merely there to be looked at, to be entertained by and to be quickly forgotten. For me they've given cause to think deep thoughts, to ask life's Big Questions, to believe there is something greater than myself – greater than ourselves – of which we are merely a part. That greater *something* may be the future, pure and unblemished, awaiting the imprint of time with the potential to be so much greater than what has gone before. I'm certain I will never know the answers to those questions, but at least I know there *are* questions – with answers — and there are dreams, and goals still to be sought.

FACING PAGE
Dummy for Can You Hear a Shout in Space?

Scholastic, 2000
Graphite pencil on paper
10in x 8in (25cm x 20cm)

For more about this see lower caption on page 66.

BELOW
A Cape Canaveral Diary

Analog, 1992
Pen & ink on watercolour paper
7in x 5.75in (18cm x 15cm)

For the August 1992 issue of *Analog* 1 wrote and illustrat-
ed a cover story about my involvement as a NASA artist
in the Space Transport System Mission #37 (in layman's
terms, the 37th Space Shuttle mission). One of the
primary goals of this mission was for *Atlantis* to place the
Gamma Ray Observatory into orbit. In the drawing we
see *Atlantis* jettisoning its solid-fuel boosters at an altitude
of about 30 miles (50km). At about 59 miles (95km), the
main tank is released to burn up as it falls to Earth.

FUTURE REAL

I CREATED MY FIRST non-sf illustration in 1969 for a foil stamping to commemorate the first lunar landing. It was completed in mid-May, two months before the actual event, and thus was still in some respects a conjectural work, in keeping with my usual proclivity.

Creating paintings of objects on the edge of development is something I have done throughout my entire career since then. It's not quite as much fun as making things up out of whole cloth, but it's always interesting to see the ways in which my paintings differ from the genuine articles when they eventually materialize.

If I have a complaint at all about the machines that human beings send off into space it is that they all too often resemble so much glorified plumbing. In space, hardware can assume almost any shape so long as it is functional. Given that absolute freedom, a freedom unavailable to objects that are built for use on Earth, it's just a matter of time before our sense of aesthetics will take hold, giving rein to objects of ethereal beauty. The future may indeed be hell (at least to the sf writer whose work depends on the need for conflict), but it will *look* spectacular.

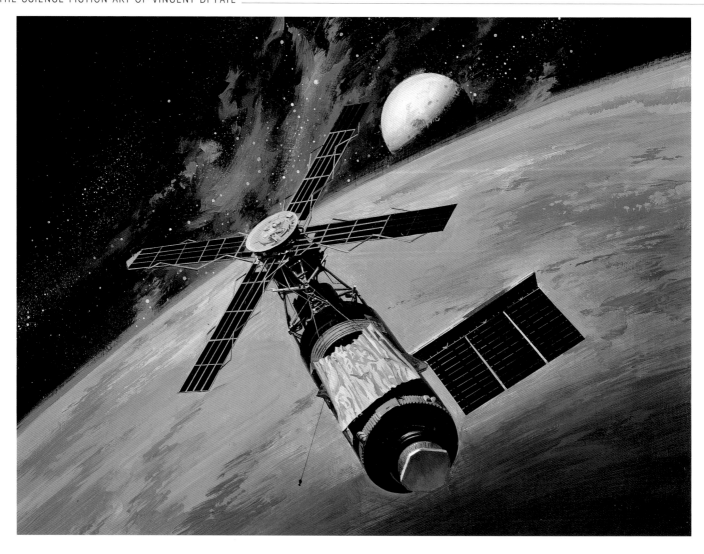

ABOVE
Skylab
From *Can You Hear a Shout in Space?*, Scholastic, 2000
Acrylics on hardboard
14in x 11.5in (36cm x 29cm)

Skylab was a valiant early attempt to place a US space station in orbit. It was launched in May 1973 with great expectations, but burned up unceremoniously some six years later when it fell to earth, its early demise due to an unexpected increase in sunspot activity. On the printed page this art originally depicted an Apollo Command Module approaching to dock, but I never much cared for the clash between the sleek Apollo and the almost Victorian look of the crude wire-and-foil Skylab. With its solar panels outstretched to drink in the sunlight, it conjures a vision of a windmill straight from the pages of Cervantes's *Don Quixote*.

RIGHT
Galileo Probe
From *Our Universe*, National Geographic Society, 1979
Acrylics on hardboard
Approx. 16in x 24in (41cm x 61cm)

I did seven paintings for *Our Universe*, and this one was probably the most successful. When a book of this sort is 'vetted' for scientific accuracy by the boys at the Jet Propulsion Laboratory in Pasadena, mere illustrators like myself – far more focused on aesthetic issues than on the minutia of precision! – can be driven mad. (One unfortunate painting involved the Viking probe to Mars. Each rock in my illustration had to resemble those visible from the lander in relative size, shape and distance from each other, yet be shown as from several hundred feet up.) Since the Galileo Probe was still on the drawing board back in 1979, there really wasn't too much to screw up. I worked from a rough free-hand drawing hastily scribbled by the mission's information officer. After its appearance in book form, the art ended up on the cover of NASA's mission profile when the probe was finally launched, nearly a decade later.

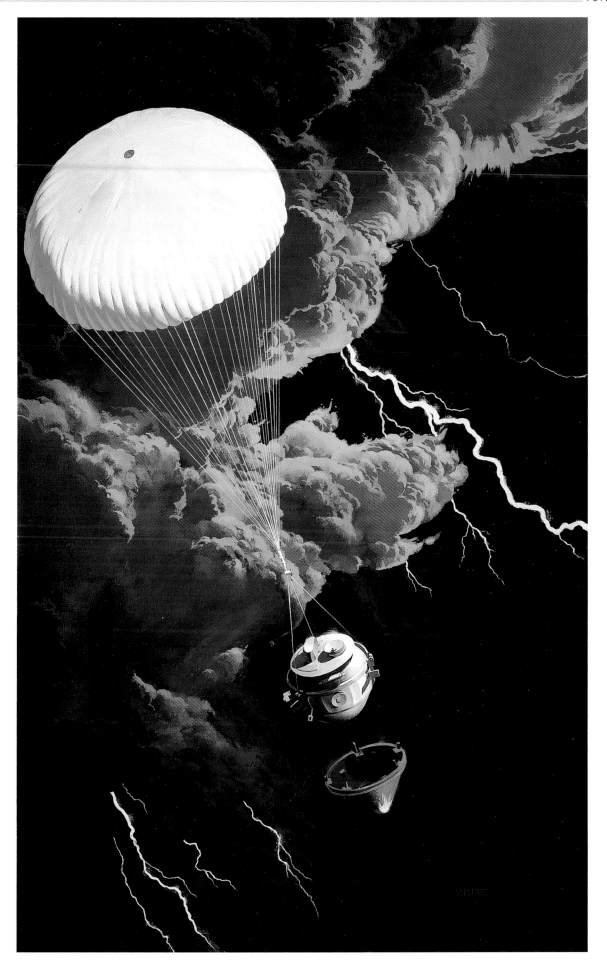

ABOVE
Saturn from Iapetus
Reco International, 1998
Acrylics on hardboard
14in x 14in (36cm x 36cm)

Because of its unique characteristics, Iapetus is a subject that I revisit frequently. In this instance I'd had a call from a company that specializes in fine collectibles, asking if I'd be interesting in creating a collectors' plate series showing the 'seven planets of the Solar System'. It took twenty minutes for me to convince the caller that there were at least *nine* known planets, not seven, and at one point I had to resort to naming them in order to prove my point! Saturn appears much larger in this painting than it would from the surface of Iapetus, but, relative to the client's limited knowledge of the subject, I could have been asked to do something far worse than merely enlarge the planet's size. The blue sky is a result of the transfer process, accomplished by use of a decal.

LEFT
Space Telescope

From *Our Universe*, National Geographic Society, 1979
Acrylics on hardboard
19.5in x 9in (50cm x 23cm)

This painting of the Hubble Space Telescope was another I
did for *Our Universe*; again, at the time I worked on it there
was no Hubble Telescope save a few diagrams and Edwin
Hubble's enduring dream, then already some thirty years old.
After its initial publication the painting had quite a remarkable
shelf life. It appeared in a number of NASA publications and,
most recently, on a 60-cent US postage stamp issued in July
2000. Despite its uncertain start (the telescope had problems
with an improperly ground lens immediately following its
deployment), the Hubble has dramatically increased our
knowledge of the cosmos and provided additional evidence
of such things as black holes and dark matter – exotic
features of the universe that were previously only topics of
speculation.

BELOW
Saturn from Iapetus

Study for a mural, 1990
Acrylics on wood
24in x 12in (61cm x 30cm)

Iapetus, one of the moons of Saturn, is of interest for several reasons. For starters, it trav-
els around its primary in an orbit substantially more inclined than do the rest of Saturn's
many moons, affording a better view of the planet's majestic ring system; the other moons
move so tightly in Saturn's equatorial plane that the rings are usually seen only edge-on
from their surfaces. Another interesting feature is that Iapetus appears brighter in one
hemisphere than the other, fuelling speculation that the moon may have been struck by a
comet that deposited a layer of frozen methane across nearly half of its surface. This paint-
ing is a rather fanciful view of the dividing line between the two surfaces, and is based on
a cover I'd done for *Analog* some years earlier to illustrate a wonderful short story by Poul
Anderson, 'The Saturn Game'.

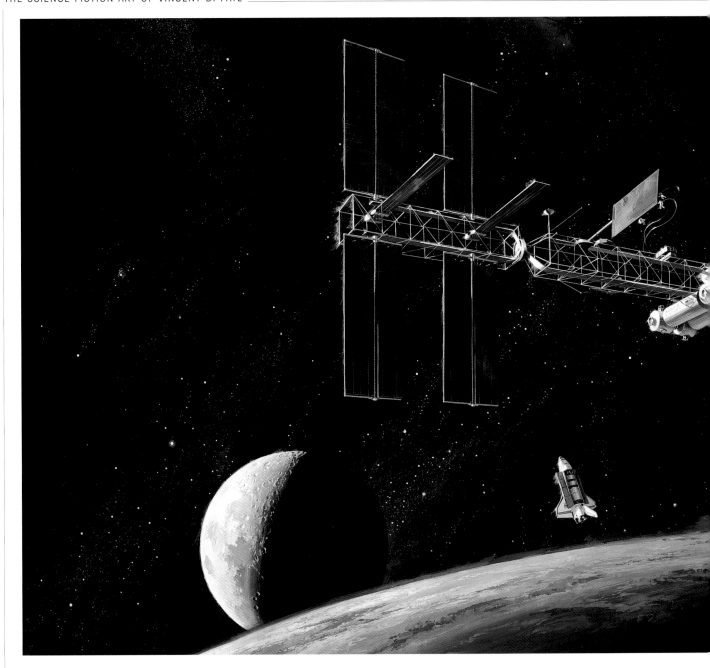

RIGHT
International Space Station
Sketch, 1985
Acrylics on hardboard
12in x 8in (30cm x 20cm)

This sketch was created prior to the construction of the model.

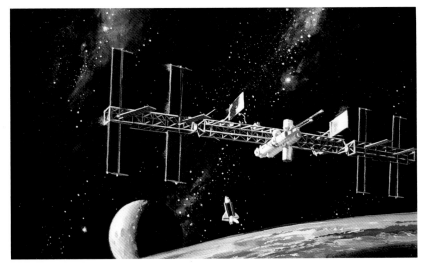

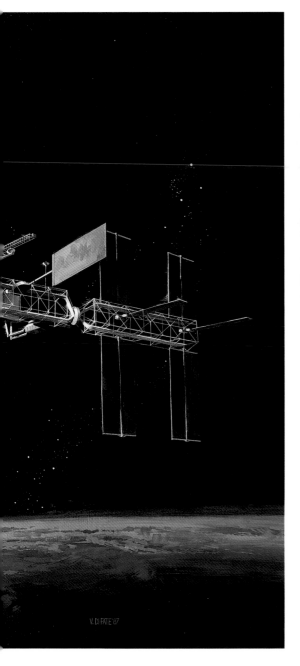

International Space Station

NASA Fine Arts Collection, 1987
Acrylics on hardboard
Approx. 72in x 48in (183cm x 122cm)

Shortly after Ronald Reagan's controversial 'Star Wars' speech, I got a call from Bob Schulman, then the director of NASA's Fine Arts Program, asking if I'd like to do a painting of the International Space Station, at the time called *Freedom*. Of course, I accepted the commission instantly, and it was one of the very few times I actually prepared a scratch model to paint from. The model became enormously useful, as Congress cut appropriations for the project almost daily during the nearly two years before the painting was finally completed: as the configuration of the station changed, I merely removed and discarded the unused parts.

International Space Station

Model, 1985
Wooden dowels, balsa wood
Approx. 36in x 9in x 30in (91cm x 23cm x 76cm)

This is a front view of my 'home-grown' *Freedom* model. The model was build from wooden dowels and balsa panels using a modeller's schematic as a guide.

International Space Station Under Construction

*Popular Science, 1987
Acrylics on hardboard
32in x 10in (81cm x 25cm)*

Hot on the heels of the NASA commission, *Popular Science* asked me to create this serial painting showing a possible progression for the assembly of the space station in Earth orbit. Given the actuality of these events as they unfolded on TV, this all seems so wildly speculative now.

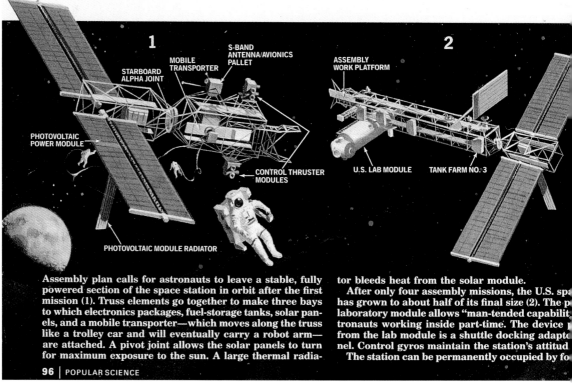

1

S-BAND ANTENNA/AVIONICS PALLET
MOBILE TRANSPORTER
STARBOARD ALPHA JOINT
PHOTOVOLTAIC POWER MODULE
CONTROL THRUSTER MODULES
PHOTOVOLTAIC MODULE RADIATOR

2

ASSEMBLY WORK PLATFORM
U.S. LAB MODULE
TANK FARM NO. 3

Assembly plan calls for astronauts to leave a stable, fully powered section of the space station in orbit after the first mission (1). Truss elements go together to make three bays to which electronics packages, fuel-storage tanks, solar panels, and a mobile transporter—which moves along the truss like a trolley car and will eventually carry a robot arm— are attached. A pivot joint allows the solar panels to turn for maximum exposure to the sun. A large thermal radia-

tor bleeds heat from the solar module.
After only four assembly missions, the U.S. sp_ has grown to about half of its final size (2). The p_ laboratory module allows "man-tended capabilit_ tronauts working inside part-time. The device _ from the lab module is a shuttle docking adapt_ nel. Control gyros maintain the station's attitud_ The station can be permanently occupied by fo_

96 | POPULAR SCIENCE

SCHOLASTIC QUESTION AND ANSWER SERIES **Q&A**

CAN YOU HEAR A SHOUT IN SPACE?
Questions and Answers About Space Exploration

MELVIN AND GILDA BERGER · ILLUSTRATED BY VINCENT DI FATE

SCHOLASTIC

REPAIR OF HUBBLE ORBITER IS RELATIV_
BLACK BACKGROUND EXTENDS TO P.28

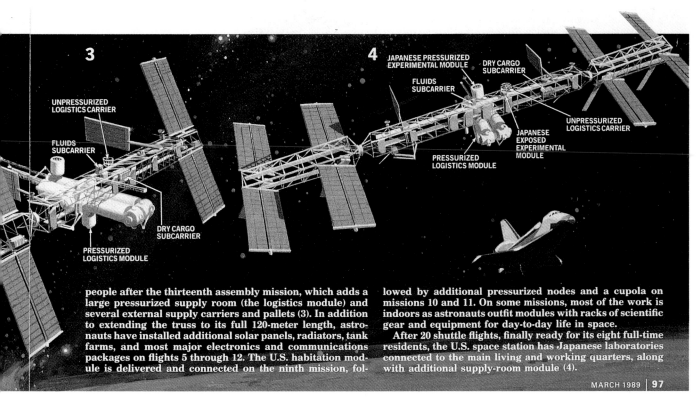

3 UNPRESSURIZED LOGISTICS CARRIER

FLUIDS SUBCARRIER

DRY CARGO SUBCARRIER

PRESSURIZED LOGISTICS MODULE

4 JAPANESE PRESSURIZED EXPERIMENTAL MODULE

DRY CARGO SUBCARRIER

FLUIDS SUBCARRIER

UNPRESSURIZED LOGISTICS CARRIER

JAPANESE EXPOSED EXPERIMENTAL MODULE

PRESSURIZED LOGISTICS MODULE

people after the thirteenth assembly mission, which adds a large pressurized supply room (the logistics module) and several external supply carriers and pallets (3). In addition to extending the truss to its full 120-meter length, astronauts have installed additional solar panels, radiators, tank farms, and most major electronics and communications packages on flights 5 through 12. The U.S. habitation module is delivered and connected on the ninth mission, fol-lowed by additional pressurized nodes and a cupola on missions 10 and 11. On some missions, most of the work is indoors as astronauts outfit modules with racks of scientific gear and equipment for day-to-day life in space.

After 20 shuttle flights, finally ready for its eight full-time residents, the U.S. space station has Japanese laboratories connected to the main living and working quarters, along with additional supply-room module (4).

MARCH 1989 | **97**

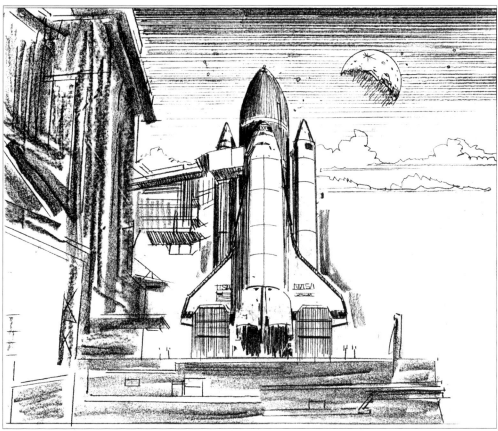

Dummy for Can You Hear a Shout in Space?

Scholastic, 2000
Graphite pencil on paper
Each 10in x 8in (25cm x 20cm)
Prior to illustrating a children's book, the artist produces a dummy containing sketches of all the key images. The dummy is enormously informative in terms of establishing the relationship of pictures to text and in creating a visual flow from page to page.

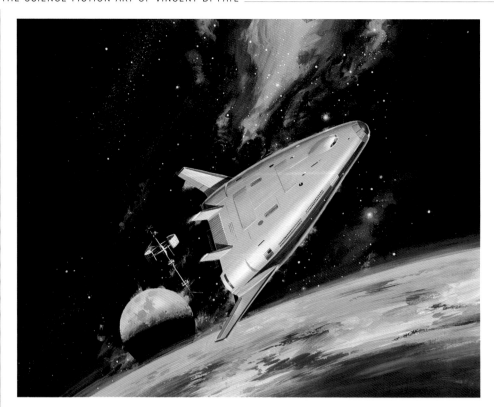

The X–33

Cover illustration for *Can You Hear a Shout in Space?*, Scholastic, 2000
Acrylics on hardboard
18.5in x 15in (47cm x 38cm)

The X–33 is one of several space-planes currently under development by the US Government that do not require a separate launch vehicle to lift them into Earth orbit. The X–33, and another vehicle, the DC–X, are both front-runners in the competition to replace the ageing Space Shuttle, though neither has fared particularly well so far in tests. Here the X–33 is shown moving away from an orbiting space hotel before beginning its descent to Earth.

LEFT
The Lunar Rover

From *Can You Hear a Shout in Space?*, Scholastic, 2000
Acrylics on hardboard
10in x 22in (25cm x 56cm)

Getting to the Moon was difficult enough, but getting around once there required a whole new technology. The Lunar Rovers, of which there were three actually deployed during the Apollo programme, were marvels of engineering and paved the way for later generations of surface rovers that would be operated by remote control.

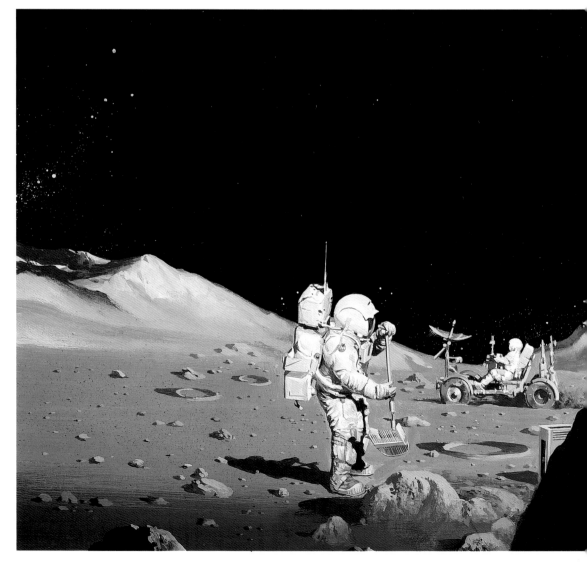

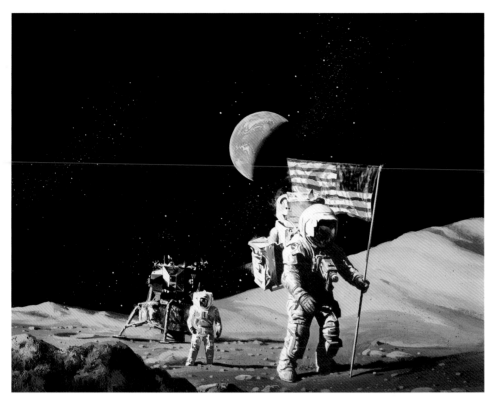

The First Lunar Landing
From *Can You Hear a Shout in Space?*,
Scholastic, 2000
Acrylics on hardboard
14in x 11.5in (36cm x 29cm)

On July 29, 1969, the day that men first
set foot on the surface of another world, I,
like millions of others, sat riveted in front
of the TV. Although I'd read dozens of
speculative accounts of that first landing
on the Moon, no one had foreseen that
the pervasive, voyeuristic eye of television
would be there to help us see the event
unfold.

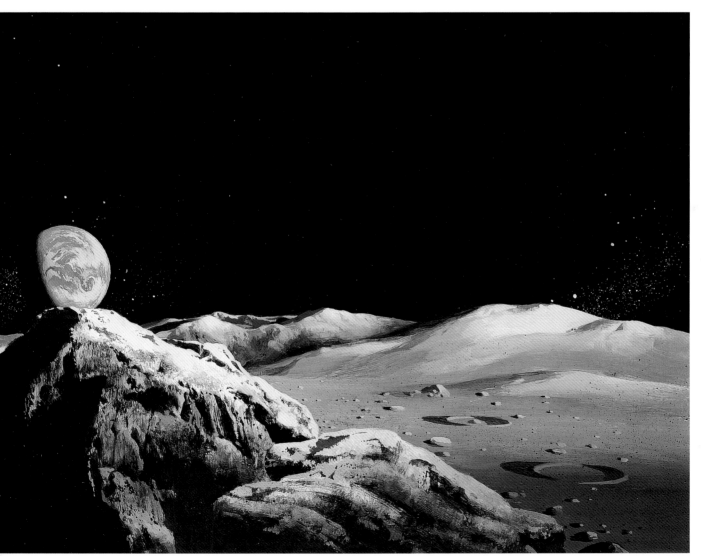

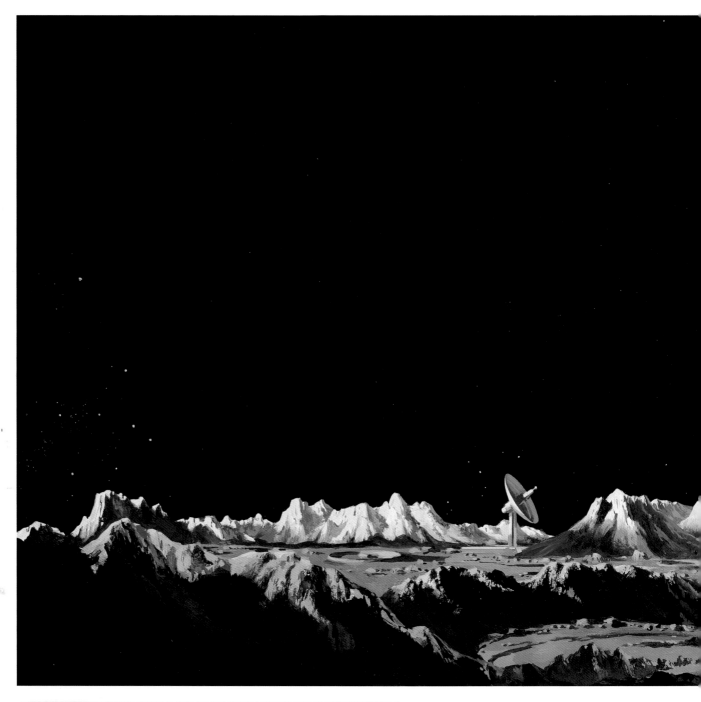

LEFT
Space Hotel

From *Can You Hear a Shout in Space?*, Scholastic, 2000
Acrylics on hardboard
22in x 10in (56cm x 25cm)

Japan has been a leader in the field of space recreation, despite an otherwise modest domestic space industry. Like computer components, much of what they produce for use in space is exported elsewhere. Among their plans for humanity's future is the Space Hotel, a veritable paradise for the cosmic tourist. When I first saw the research materials I immediately raised the question of human aesthetics: it seemed to me the way the resort *looked* would be a key factor in attracting tourists. The editors, on the other hand, were concerned about how literal their young readers would be, and were reluctant to deviate too much from the available reference. The compromise we reached is what you see here – a slightly more streamlined conglomeration of cosmic plumbing.

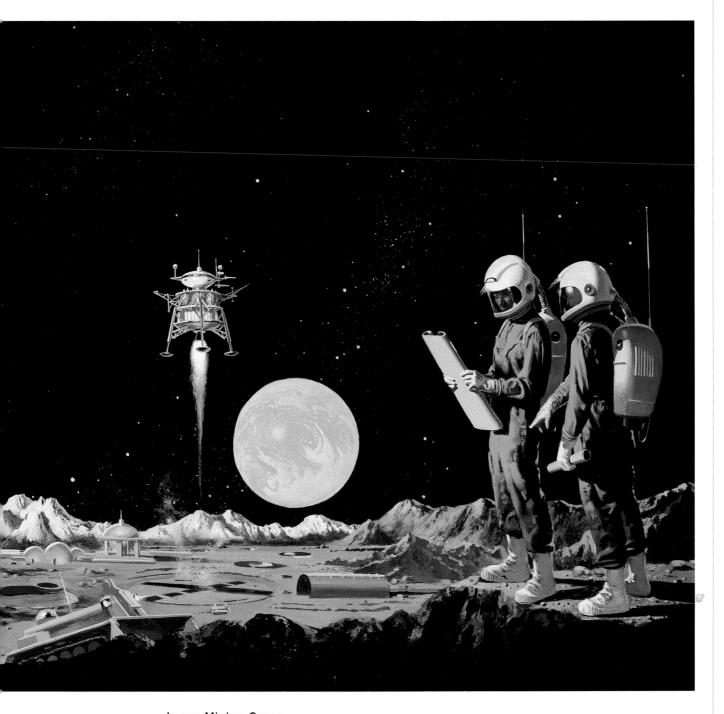

Lunar Mining Camp

From *Can You Hear a Shout in Space?*, Scholastic, 2000
Acrylics on hardboard
22in x 10in (56cm x 25cm)

Having spent so much of my life specializing in the painting of sf, I found it difficult to
restrict myself to a fact-based vision of the technological future. But the children's science-
book market, with its impressionable and highly literal audience, is of necessity – and
almost paradoxically – a limiting environment for someone like me. This lunar camp, so
reminiscent of the sort of thing I encountered in the space art of the 1950s, was as far out
as I was permitted to go. While the reality of this scene is still some decades off, I would
never have guessed as a youngster how restricted our vision of space would ultimately
become.

The Solar System

From *Do Stars Have Points?*, Scholastic, 2000
Acrylics on hardboard
22in x 10in (56cm x 25cm)

When I was a youngster a very impressive illustrated series appeared in *Life Magazine* entitled 'The World We Live In'. It was about the Earth, its formation, evolution and various lifeforms, and its ultimate place in the Solar System, the Galaxy and the cosmos beyond (or at least as it was understood in the 1950s). For the instalment on the planets there was a thrilling gatefold image painted by the great Chesley Bonestell that utterly captivated me. It showed the planets in proportion and in order of distance from the Sun, but most impressive of all was the sheer enormity of the Sun itself, which was far too large to be shown in its entirety. This painting is my own take on that great image. No one will ever do it better – or even as well – as Bonestell, but it was a joy, and a dream come true, to have given it a try.

The Planets

From *Do Stars Have Points?*, Scholastic, 2000
Acrylics on hardboard
20in x 8.75in (51cm x 22cm)
Accompanying the painting of the Solar System were these renderings of the planets – sleek, clean, well defined and completely devoid of embellishments or backgrounds. Amazingly, in this Spartan view, the arresting beauty of the solar family is revealed with a startling clarity.

ABOVE
Abandon in Place
Sketch, 2000
Acrylics on mounted Acryla-Weave
9in x 7in (23cm x 18cm)

While I *think* the finished painting offers something more than the sketch, there's a drama and a spontaneity here that's somehow missing in the more polished version.

RIGHT
Abandon in Place
Tor, 2000
Acrylics on hardboard
24in x 17.25in (61cm x 44cm)

Jerry Oltion is a terrifically talented author of hard sf. This novel is an expansion of his Nebula Award-winning novella. The art presents a view of a real and quite familiar fixture of the Moon missions, the Lunar Module. The plume of 'smoke' is actually of water vapour vented from the surface by the intense heat of the Module's flaming exhaust.

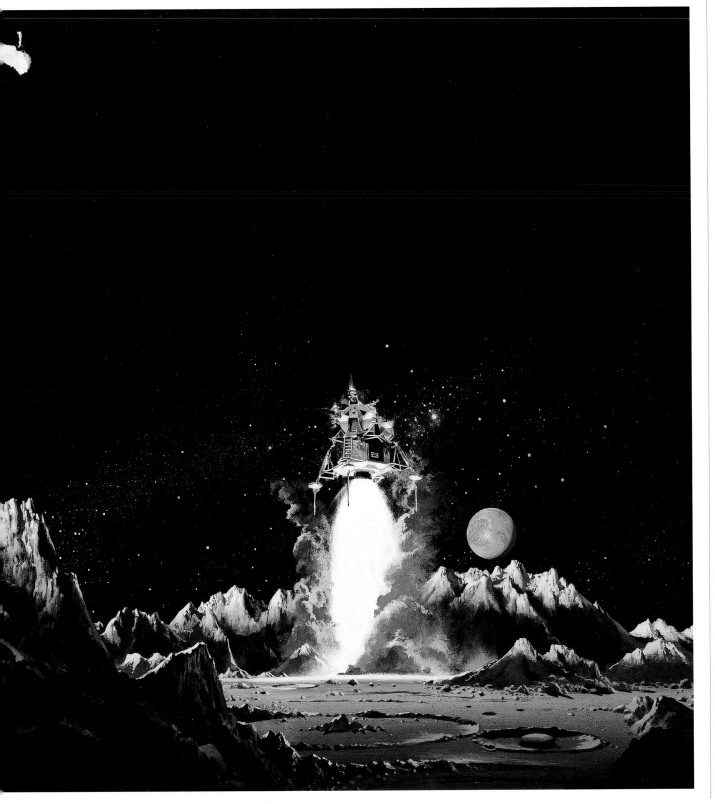

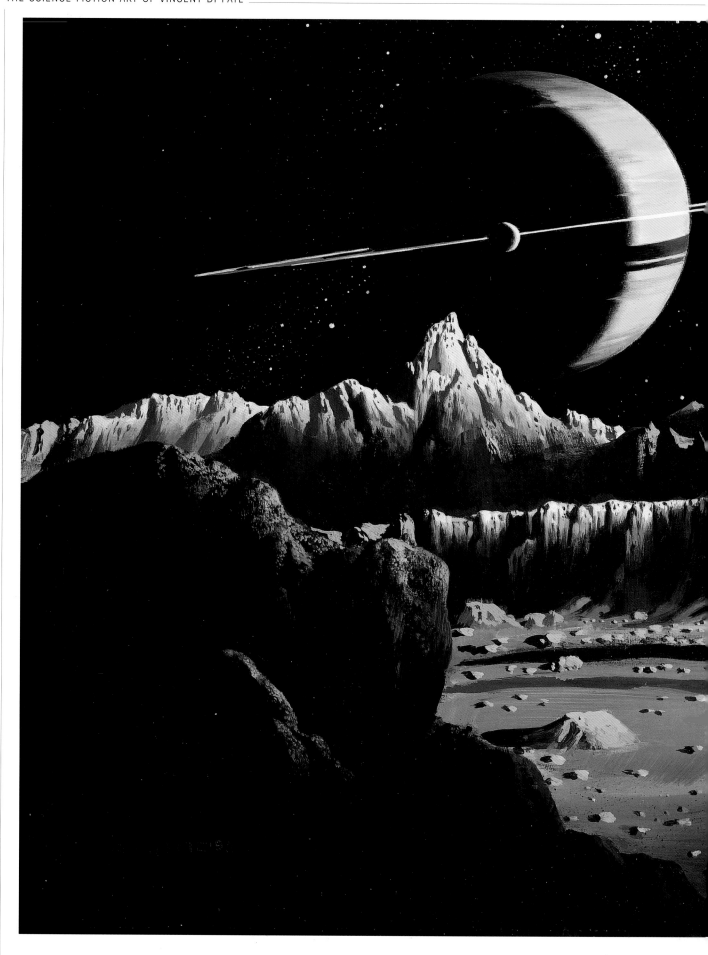

Saturn from the Tiber Chasmae

Unpublished, c1992
Acrylics on hardboard
*Approx. 15in x 12in
(38cm x 30cm)*

There's a canyon on
Dione, one of Saturn's
inner moons, that
has been formed by
repeated meteoritic
impacts, creating a
landscape of deep
recesses and precipi-
tous cliffs. From this
vantage point, Saturn
sits large and low
on the horizon, its
complex rings
reduced to a mere
sliver of brilliant light.

FANTASY AND HORROR

THINGS THAT GO BUMP IN THE NIGHT, that inhabit the dark spaces of the cellar or the forsaken corners of the attic, or that glide past the edge of sight on a chilling breeze – these things strike fear into our hearts, and even the most rational of us have no immunities to the terrors they induce. Who among us, sensible though we may be, has not felt the palpable presence, heard the soft stirring and the laboured breathing, and smelled the warm, foul breath of *something* in the room where no one else should be – something *in*human and *un*alive? The phantoms that flourish in the darkness beyond rationality have haunted us since ancient times when magic was all that existed to explain the mysteries of the world and the terrifying forces of nature.

Psychologists tell us that the appeal of the horror story lies in the fact that, through the vehicles of the printed page and the motion picture, we can experience death – and things worse than death – and emerge unscathed. They tell us that, much like a rollercoaster ride in which we defy death at every turn, this process provides release from the anxieties of our daily lives. From the tales of the tribal storyteller to the myths of ancient Egypt to the true Dark Ages when devils and witches rode the currents of the night wind, to the stories of Byron, Shelley, Hawthorne and Poe, to Bram Stoker's *Dracula*, H.P. Lovecraft's Cthulhu mythos, William Peter Blatty's *The Exorcist* and the bestsellers of Stephen King, Dean Koontz and Anne Rice, human beings have exhibited an insatiable appetite for tales of the supernatural.

Songs
Weird Tales, 2001
Pen & ink on scratchboard
7in x 10in (18cm x 25cm)

This unusual and sensitive short story by Sarah Hoyt for *Weird Tales* involves an ill-fated homosexual relationship and the subject of violent suicide. There was almost certainly a better solution to this illustration assignment than the traditional horror approach I came up with, but I couldn't for the life of me think of it.

Having been weaned on Poe and Lovecraft and exposed to the horror movies of the late 1950s and, through television, the 'classics' of the 1930s and 1940s, I fully expected that much of my creative output would be in this area. And, again, I was wrong. The same was true for fantasy, the lighter side of the magical universe. By the time my career got truly underway I was already typecast as a gadget painter, and that was that. I did, however, have a brief year or two in the very early 1970s during which I painted the covers for just about every horror novel and anthology that was published in the USA (oddly, a number somewhere well below a dozen – how times have changed).

As for fantasy, I had what I thought was an auspicious beginning at Del Rey with the cover painting for L. Sprague de Camp's *The Tritonian Ring*. Alas, any continuity I might have hoped for was simply not to be. Judy-Lynn del Rey died unexpectedly at work a few years later (1986), and I was just too busy painting gadgets in double-quick time to notice that my career in fantasy illustration had ended abruptly with her untimely death.

What is collected here is all that remains of what I've done; so much of it was never returned or was scattered to the four winds. In recent years my work for *Weird Tales* and *Marion Zimmer Bradley's Fantasy Magazine* has increased the body count (mostly with interior black-and-white illustrations), but this is still a very meagre legacy at best. Not having died yet, I remain hopeful that things will change and that I'll get a fair chance to give this subject some serious attention in the future.

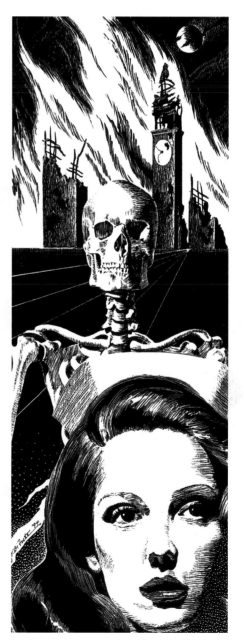

Girl with Skeleton
Worlds of Fantasy & Horror, 1994
Pen & ink on scratchboard
Approx. 6in x 12in (15cm x 30cm)

This was for Jeff VanderMeer's 'London Burning', a haunting tale of a young nurse in the London Blitz during World War II. As a work of fiction it was a grim, effective reminder of what horrors a real war can bring.

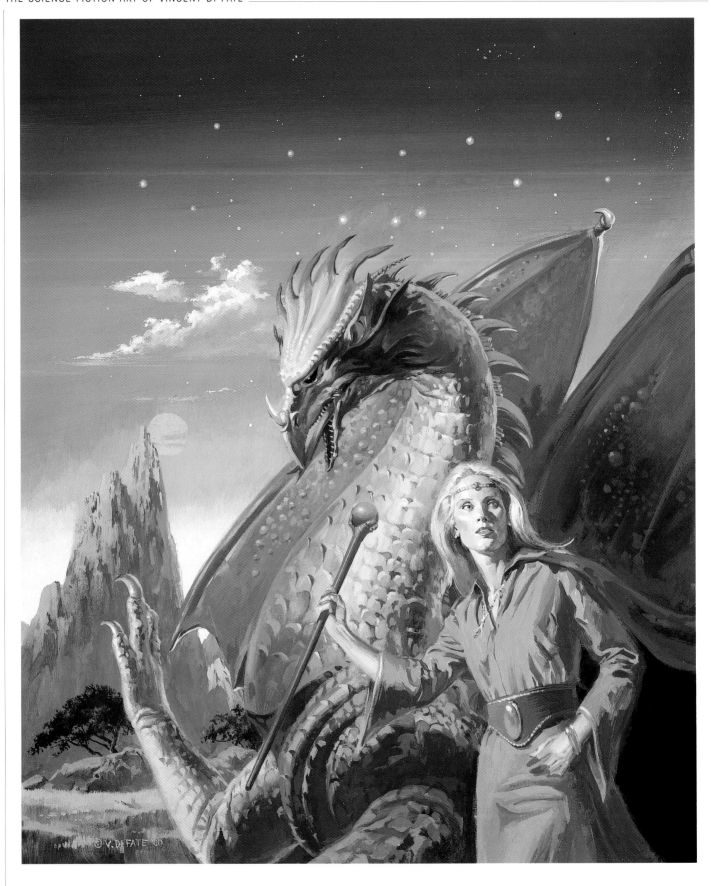

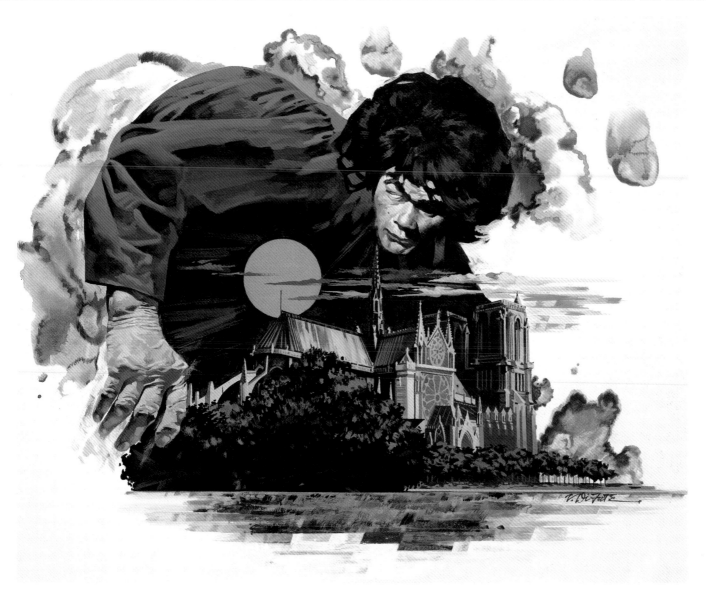

LEFT
Dragon Queen

Marion Zimmer Bradley's Fantasy Magazine, 2001
Acrylics on hardboard
Approx. 14in x 20in (36cm x 51cm)

This was the cover art for the final issue of *Marion Zimmer Bradley's Fantasy Magazine*, and it evolved out of an earlier and entirely different assignment for them. I'd received a story some five years before entitled 'Dragon-in-Law' (finished interior art and sketches for the story can be seen on page 86, along with preliminary thumbnails for the eventual cover). A contemporary fantasy, the story dealt with the trials of a newlywed whose mother-in-law is possessed of magical powers – among them the ability to transform herself into a dragon. Although the story was too short to justify a cover, I was intrigued with the idea of painting a dragon – something I'd not been asked to do since high school. Rachel Holmen, the magazine's resourceful editor, suggested I generate the painting anyway, and that they'd eventually find a slot for it. As it worked out, I could never free up the time to work on the project until in 1999, to the great sadness of everyone in the field, Ms Bradley, a brilliant fantasy author and the founder of the magazine, died. The publication had been especially aimed at cultivating new talent, but with her passing the dream ended. Rachel called to invite me to do the cover art for the last issue and, under the circumstances, I simply couldn't consider refusing. The painting was fun to do, but I wish it had been brought about by happier circumstances.

ABOVE
The Hunchback of Notre Dame

NBC–TV, c1973
Acrylics on illustration board
Approx. 14in x 10in (36cm x 25cm)

Victor Hugo's classic story of the grotesque hunchback Quasimodo and his love for the beautiful gypsy girl Esmerelda has been adapted for the screen several times – most notably in the 1923 silent starring Lon Chaney. In the early 1970s NBC made yet another attempt at it, this time as a made-for-TV movie. Working for high-pressure clients in the mass media (other than print, that is) is something for which I am seldom able to summon the temperament. What NBC needed from me was a small painting to promote the film to their national affiliates and, after much anguish and alteration, this is what we ended up with. I have avoided viewing this particular movie for personal reasons, but I've been told that, though modest in production values, it is quite good.

Passing the Narrows
Weird Tales, 2000
Pen & ink on scratchboard, fountain pen
on legal paper
7in x 10in (18cm x 25cm)
8.5in x 11in (22cm x 28cm)
6.75in x 2.5in (17cm x 6cm)

A mere five typewritten pages long, this
unsettling story by Frank Tuttle concerned a
stretch of river where, in the closing days of
the American Civil War, wounded
Confederate soldiers and their kin died as
their hospital ship was assaulted by a Union
ironclad. The ghosts of the war-dead haunt
the narrows, providing the fantastic element
of this grim narrative. The assignment called
for a single-page image and a 'running spot'
– a small piece of art that would be repeated
throughout the text at strategic points. The
spot wound up somewhat different from the
two thumbnails in my page of sketches, and
I'm not entirely certain this was an improve-
ment. One of the troubling disadvantages of
working to deadline is that one seldom has
the luxury to rethink an image before the
clock runs out.

The Tritonian Ring

Ballantine/Del Rey, 1978
Acrylics on hardboard
Approx. 14.25in x 19in (36cm x 48cm)

This L. Sprague de Camp novel was a joy to illustrate, and I thought my cover painting would be the start of a new direction in my work. Unfortunately, that never fully materialized, for by the late 1970s I'd already become categorized as a 'gadget' artist. But there's something about the crystal clarity of the sky in a classic fantasy painting that I find truly delightful – that master talents like Maxfield Parrish could produce so effortlessly and so perfectly. I often wonder where this path might have taken me had I continued along it.

© V. DI FATE '80

Assignment in Eternity

New American Library, 1980
Acrylics on hardboard
Approx. 16in x 23in (41cm x 58cm)

This collection of short stories by Robert A. Heinlein is rather far removed from fantasy, but using the traditional fantasy icon of an angel seemed to fit. The idea here is that the atomic blaster stuffed into the young lady's belt serves to bridge the gap between these two subgenres of fantastic fiction.

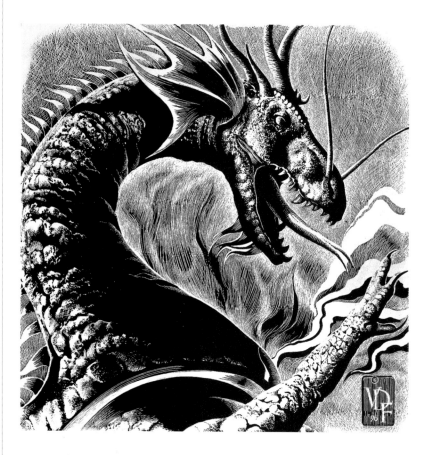

Dragon-in-Law

Marion Zimmer Bradley's Fantasy Magazine, 1996
Pen & ink on scratchboard
Illustration: 9.375in x 9.75in (24cm x 25cm)
Sketch: Approx. 17in x 11in (43cm x 28cm)

'Dragon-in-Law' is a delightful short story by Connie Hirsch that deals with a woman whose mother-in-law is able to transform herself into a fire-breathing dragon. Since I so seldom get to work with such fanciful material, I let my imagination go during the early phase of the assignment. Here you see not only the evolution of the drawings for the story, but the beginnings of a cover painting that I would eventually produce for the magazine some five years later (see page 81).

HARACTER - BARBARA CHANT
ET - MRS. SMAEL
ND - PAUL

#2 - HORIZONTAL

BOSTON
SKYLINE

BARBARA
MEETS
MRS. SMAEL

AY -

DRAGON
CLAW IN
BG -

$5\frac{1}{4}" \times 6\frac{1}{4}"$

MRS. SMAEL

DRAGON-IN-LAW
POSSIBLE
COVER

M2B FANTASY MAGAZINE

HOLD

HOLD FOR POSSIBLE FUTURE
USE

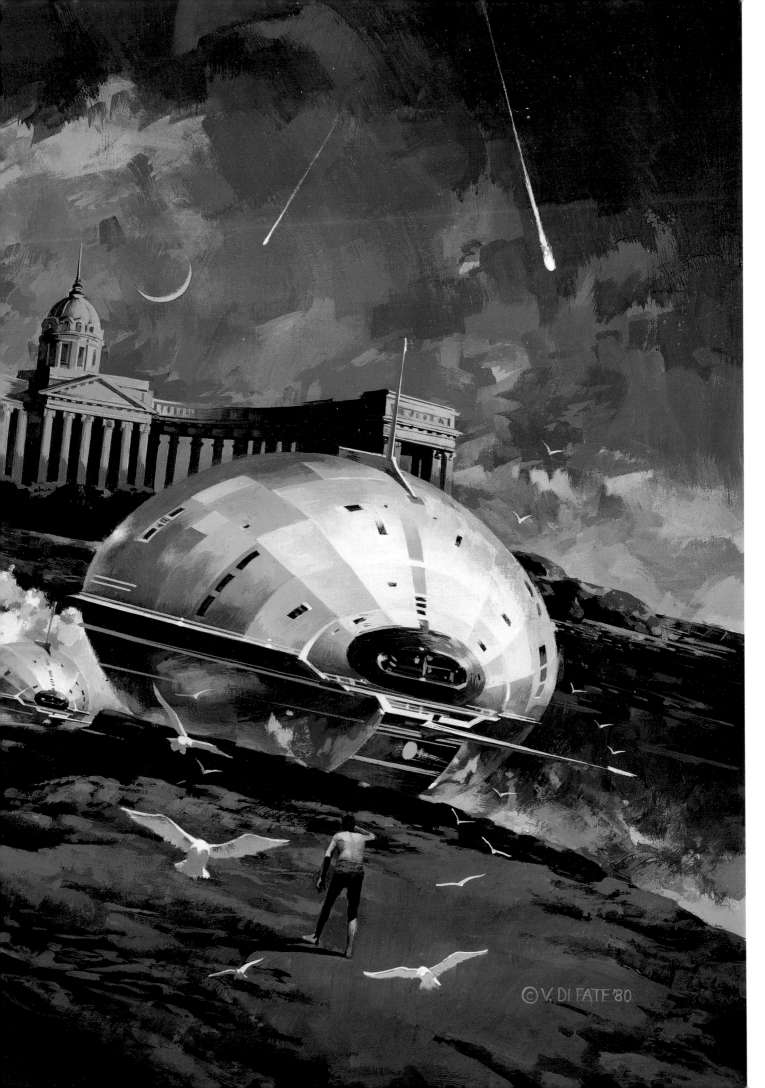

©V. DI FATE '80

Shadows on the Sky – the Early Flying Saucer Era

A longer and substantially different version of this essay appeared in issues #22 and #23 of *Outré* (Winter-Spring 2001).

I DON'T BELIEVE IN FLYING SAUCERS any more, but I do have an open mind about them. In the late 1940s and for most of the 1950s I was a True Believer. They were popularly known as flying saucers then, and they were in the news almost regularly. UFOs (Unidentified Flying Objects) is what we call them now, and it's apparent to me that UFO witnesses are seeing *something* – very likely many different things. Not all the people who see UFOs are crazy, and not all are hallucinating. It is my feeling that you needn't be mad or stupid or particularly gullible to believe. I suspect that many of the things we think we know about UFOs are things that we as human beings have, of necessity, invented. We are a species with a need to understand and to give meaning to the world around us, and there are times when that need leads us to imprecise or erroneous conclusions.

There was a time when UFOs were more than mere fugitive shapes against the sky; they were thought of as the sleek vessels of creatures from outer space. They plied the skies of Earth engaged in activities that were unfathomable to us. This was during an era of anxiety in a world so troubled that it was in need of rescue. We stood poised on the threshold of a future fraught with wonders and fears so boundless that anything could happen. I remember that time well. Its ominous mood drew me to a deep and uncommon love of things fantastic.

UFOs entered the pattern of my life on Sunday afternoon, April 19, 1953, although of course I'd heard of them before. On that day I'd gone with my parents to visit my grandfather, and while the family was engaged in conversation around the kitchen table I wandered off into the living room. Lying on the coffee table was a copy of *American Weekly*, a newspaper supplement, and it lay open to an article entitled 'Burned by a Flying Saucer'. Accompanying the article was an illustration of a man lying terror-stricken on the ground as a huge flying saucer hovering above discharged a fireball. When I saw it, at age seven, the picture both frightened me and left a lasting impression. I quickly closed the magazine, ran off to the kitchen and the safe company of the family, and refused to return to the living room for the rest of the day.

Although I was terrified of the subject, I found myself strangely drawn to stories about flying saucers. In those uncertain days, fear rippled everywhere throughout the media. Apocalyptic visions in books, magazines and movies offered a way to consider the unthinkable vicariously as we attempted to make sense of the looming nuclear shadow under which we had come to live. As a kid I had only the frailest grasp that these grim fantasies, presented in the context of the arts, were intended to be entertaining. I thought of them as essentially real.

Meanwhile, in the larger world, an ugly reality began to emerge. In the late 1940s the USA and the USSR, allies during World War II, found themselves at ideological odds. For myriad reasons, relations between the two superpowers began to deteriorate into a precarious Cold War that would last for nearly forty years. In the winter of 1948, after a number of confrontational disputes over the disposition of Germany and much of central Europe, radiation was detected from the first Soviet atomic test. Moreover, by the early 1950s it was discovered that the Soviet nuclear-weapons programme had been built using elaborate espionage to steal atomic secrets from the USA.

Long before these facts were known, Wisconsin Senator Joseph R. McCarthy had levelled accusations against the US State Department, the Army and other agencies of the government, claiming that they'd been infiltrated by American communists sympathetic to the USSR. In a period of just over four years, beginning in February 1950, McCarthy managed to establish personal veto power over the hiring

FACING PAGE
Out of the Deeps
Workman, 1980
Acrylics on hardboard
9in x 12.75in (23cm x 32cm)

John Wyndham Beynon Harris (who wrote under various names including John Wyndham) was a masterful writer and a devotee of the great H.G. Wells. In this novel, originally titled *When the Kraken Wakes* (1951), Wyndham effectively dealt with correcting certain aspects of Wells's classic alien-invasion novel, *The War of the Worlds* (1897), that had since become scientifically suspect. Wells's Martians were octopoidal (no doubt inspired by Giovanni Schiaparelli's pronouncement that Mars was crisscrossed by *canali*, or 'channels'), and Wyndham reasoned that, if the invaders were aquatic, they were more likely to launch their invasion of Earth from the sea. In this scene, a sea tank (a bizarre biomechanical nightmare of a weapon) rumbles up on land to the horror and amazement of a solitary beachcomber. In addition to bearing a formidable ramming spar, these awesome machines expel organic weapons – coelenterate or jellyfish-like projectiles – that envelop and dissolve their prey with their digestive acids.

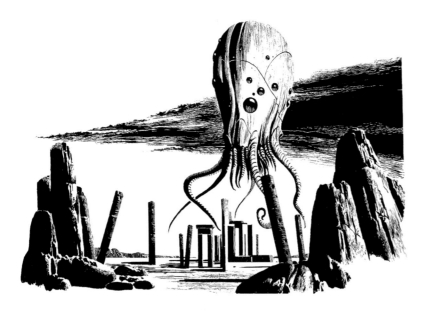

Elephants' Graveyard
Analog, c1996
Pen & ink on scratchboard
10.5in x 7.5in (27cm x 19cm)

An ancient alien burial ground
played a key role in this
atmospheric short story by
David Alexander and Hayford
Pierce.

FACING PAGE
The War of the Worlds
Platt & Munk, 1978
Acrylics on hardboard
14in x 18.75in (36cm x 48cm)

In 1897 H.G. Wells wrote the
world's most enduring novel
of alien invasion, with its
octopoidal Martians, lethally
efficient heat rays and invinci-
ble walking war machines.
His vision of the world
besieged was so vivid and so
terrifying that its adaptation
to radio some forty years later
caused widescale panic.
Throughout the first full
decade of the Flying Saucer
Era, consultants for Project
Sign frequently cited the field
studies carried out in the
wake of 'the Martian
Broadcast' as a barometer of
public reaction to the idea of
alien visitors.

and firing of employees at the State Department,
imposed his beliefs on US foreign policy, drove
four senators who opposed him out of office
and accused presidents Harry S Truman and
Dwight D. Eisenhower of treason. In all but the
most sympathetic accounts, McCarthy is
remembered as a demagogue whose ruthless
inquisitorial manner and indiscriminate accusa-
tions ushered in an era of distrust. The paranoia
that followed seeped into almost every aspect of
America life and resulted in the undoing of the
careers of hundreds of innocent people.

Invaders from Mars (1953), *Invasion of the
Body Snatchers* (1955) and other films of their
kind were merely an exaggeration of the daily
headlines and of the growing perception that
evil forces were infiltrating every segment of
society. In those oddly tense times, made all the
more perilous by our naive belief that a nuclear
war was survivable, science began to uncover a
reality so astonishing that almost anything
seemed possible. Most of us were blissfully
ignorant of what was being revealed at the cut-
ting edge of science, yet the media was abuzz
with speculations about an odd assortment of
exotic possibilities. These ideas have since
become ingrained in our popular culture – and
flying saucers, and the Little Green Men who are
their purported pilots, are among them.

☆ ☆ ☆

As absurd as the idea of Little Green Men
seemed and as publicly scorned as it was, a fair
number of people within the US military estab-
lishment took the subject seriously. According
to Edward J. Ruppelt's landmark book *The*

Report on Unidentified Flying Objects (1956), for a
few years nearly half of those at the Air Force's
Air Technical Intelligence Center (ATIC) who
had access to classified information held the
belief that UFOs were both of extraterrestrial
origin and of hostile intent. In an 'Estimate of
the Situation', a document classified as
top-secret when it was issued in late July 1948,
the conclusion was tendered, based on thirteen
months of secret study, that flying saucers were
real and that they were from outer space. This
has come to be known as the *extraterrestrial
hypothesis*.

Although UFOs were not unheard-of when
Kenneth Arnold gazed out the window of his
private plane on a clear Tuesday afternoon to see
them for himself, no single event in history did
more to catapult the subject into the public eye.
Arnold, proprietor of the Great Western Fire
Control Supply of Boise, Idaho, took off from
Chehalis, Washington, on June 24, 1947, on a
flight to Yakima. By 3:00pm his course had
taken him into the vicinity of Mount Rainier
where a C-46 Marine transport had recently
gone down, and Arnold decided to reconnoitre
briefly before continuing. After only a few min-
utes he was attracted by bright flashes of light to
his left, just to the north of Mount Rainier.
There he observed a column of nine bright, flat-
tened disc-shaped objects travelling in a reverse-
echelon formation (the lead object being in the
highest position with the rest stepped down to
the trailing end of the line) and moving south-
ward across his path. As they proceeded they
zigzagged in and out of the mountain peaks
with a skittering motion that Arnold later
described as looking 'like saucers skipping over
the water'. It was this expression, and not
Arnold's description of the discs, that gave rise
to the term 'flying saucers' – indeed, he later
clarified in his book *The Coming of the Saucers*
(1952) that the discs he saw were actually cres-
cent-shaped.

While the objects were still in sight, Arnold
made a notation on his map of their position
and noted the time. At one point the discs
passed behind a mountain peak, giving him a
good idea of how far away they were. When he
landed in Yakima later that afternoon he
sketched the flight path of the objects on his
map and discovered that they'd travelled
approximately 47 (76km) miles during the 102
seconds that had elapsed between the time he

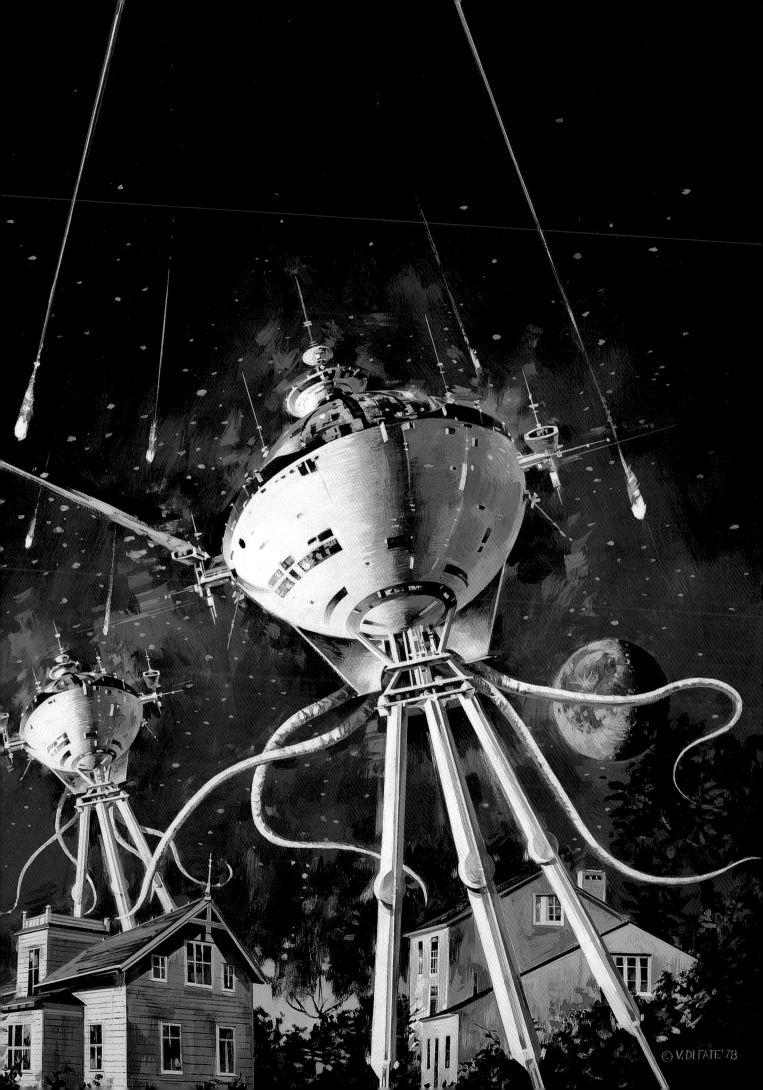

© V. DI FATE '78

started making notations and the discs' disappearance from view. From this information, taking into account his estimated distance from the objects of 20–25 miles (32–40km), Arnold was able to calculate their speed at an astonishing 1700mph (2700kph). His initial thought was that he'd seen some secret military aircraft being tested in the isolation of the Cascade Mountains. The known maximum speed of most of the world's aircraft was much lower, well below 600mph (970kph), until sometime after the end of World War II, so the speed of the discs was the most compelling factor in establishing their extraordinary nature. Arnold's credibility as an experienced pilot and a reliable witness put the incident in the national headlines.

Despite his trustworthiness, questions arose over his account of the sighting. Arnold estimated the discs as 45–50ft (14–15m) long, yet at the distance he claimed to have seen them they would have been too small to be visible to the naked eye. Were he correct in his size estimate, the objects would have been much closer to him and, thus, travelling much slower. Months after the sighting, ATIC experts at Wright-Patterson Field in Dayton, Ohio, recalculated on the assumption that the objects were closer, and came up with an airspeed of about 400mph (640kph) – a speed consistent with that of conventional jet planes of the period. ATIC authorities speculated that Arnold had observed a formation of conventional jet planes through layers of air of varying temperatures, so that their images were distorted and shimmered in the way he had described.

Challenging this interpretation were the facts that Arnold was a seasoned pilot, familiar with the region, and that the objects passed behind a mountain peak, thus establishing the probable accuracy of his estimate of distance. If he had indeed seen extraordinary aircraft at a distance of some 25 miles (40km), then the size of the objects must have been substantially greater than he thought. ATIC experts calculated their length, in this scenario, to be a minimum of 210ft (64m).

Over the half-century or more since the sighting there have been many explanations offered as to what Arnold observed, one of the most recent being that he witnessed the fragmenting of a large meteorite as it plummeted to earth.

☆ ☆ ☆

Although there were many significant reports by credible witnesses hot on the heels of the Arnold sighting, the next important story to attain longevity in UFO lore is one that still remains with us and that actually continues to unfold. The story began with an official press release issued on July 8, 1947, by US Army 1st Lieutenant Walter Haut, the public relations officer at Roswell Field, New Mexico. The statement read, in part: 'The many rumors regarding the flying disk became a reality yesterday when the Intelligence office of the 509th Bomb Group of the Eighth Air Force, Roswell Army Air Field, was fortunate enough to gain possession of a disk through the cooperation of one of the local ranchers and the sheriff's office of Chaves County.' The release was written and dispatched at the request of the Roswell base commander, Colonel William Blanchard, but was retracted later in a statement that identified the flying disc as debris from the radar reflector of a stray weather balloon. On the strength of this new information, the story was summarily forgotten.

The subject remained dormant for 33 years until the 1980 publication of *The Roswell Incident* by William L. Moore and Charles Berlitz. Berlitz had achieved international notoriety six years earlier with his controversial book *The Bermuda Triangle* (1974). In *The Roswell Incident* the authors told an extraordinary tale of a crashed flying saucer, of the retrieval of alien crew members, both living and dead, and of an elaborate government effort to conceal the incident from the public. The story has since been embellished by articles, books, movies and TV documentaries to include a mid-air collision of two saucers and claims of additional crash sites. The community of Roswell has since become a flourishing tourist attraction despite the fact that it is some 75 miles (120km) southeast of the place where the original debris was found.

Although there are conflicting claims surrounding the incident, the surviving documented facts are relatively few. They begin with William W. 'Mac' Brazel, who managed the Foster ranch near Corona, New Mexico. According to an interview with Brazel in the July 9, 1947, issue of the *Roswell Daily Record*, on June 14 he retrieved debris that had been strewn over an area of his ranch several feet in width and about 600ft (185m) long. The materials he found consisted of scraps of paper coat-

ed with a foil-like substance, small sticks, a quantity of Scotch tape, some additional tape with a flowered pattern, and shards of grey rubber. Not knowing what these materials were for or where they had come from, he went to nearby Corona on the evening of July 5 to discuss his find with his uncle, Hollis Wilson. Wilson and a friend informed Brazel of the recent rash of flying-saucer sightings and offered the possibility that the debris might have come from one of them. The following day Brazel drove the hour and a half to Roswell and told his story to Sheriff George A. Wilcox, who then phoned authorities at Roswell Army Air Field.

Taking the call was base intelligence officer Major Jesse Marcel, whose remarks in later years ultimately sparked renewed interest in the incident. Marcel met with Brazel and reported the details of their meeting to base commander Blanchard. In his account thirty years later, Marcel claimed that both he and Blanchard were in agreement, based on the Brazel interview, that the debris seemed to be from some unusual kind of aircraft. Later on July 6, Marcel and an Army Counter Intelligence Corps officer returned with Brazel to the Foster ranch. The following morning, Marcel and the CIC agent collected samples of the debris and brought them to the base in the agent's Jeep carryall and in Marcel's staff car. The samples were put on a B-29 and flown to Wright-Patterson Field after a layover at Carswell Army Air Field in Fort Worth, Texas. Marcel accompanied the materials as far as Fort Worth.

Marcel's description of the debris differs somewhat from Brazel's. The bulk of the materials, Marcel claimed, were many small scraps of tinfoil-like metal that were extremely strong and dent-resistant. There was also a quantity of brownish parchment-like material and some small beams that resembled balsa wood, but were clearly not balsa. On pieces of the debris there were some unusual pink and purple markings, resembling hieroglyphics. Although Marcel died shortly after breaking his silence, in the late 1970s his son Jesse Jr, 11 years old in 1947, corroborated his father's description of the retrieved materials; the senior Marcel had apparently withheld some of the fragments and brought them home, where he and his son inspected them after spreading them out on the living-room floor; when, soon afterwards, the authorities announced the retraction, Marcel

returned these materials. Jesse Marcel Jr is now a physician with experience as an aircraft accident investigator and is, in every respect, a reliable witness.

When he broke his silence in the 1970s the senior Marcel explained that, as soon as the B-29 arrived at Carswell, the materials were taken to Brigadier-General Roger Ramey, the commander of the Eighth Air Force. Ramey had samples brought to his office where press photographers were allowed to photograph them from a distance before being ushered back out of the room. After a brief delay the photographers were allowed to return, to handle the samples and to take additional pictures. By that time, according to Marcel, the samples had been switched. Warrant Officer Irving Newton, the Carswell weather officer, was now brought in to identify the samples as pieces from the radar reflector of a Rawindsonde weather balloon. But these devices were in common use, and were unlikely to have been misidentified by Marcel and others who had handled the debris prior to its arrival at Fort Worth. Marcel's comments in interviews conducted between 1977 and 1979 were the first indications of a government cover-up in the so-called Roswell incident.

The Moore/Berlitz book amplified the story of 'Mac' Brazel's find to include the eyewitness account by Dan Wilmot and his wife of what they had seen on the evening of July 2, 1947: a brightly luminous object streaking across the night sky at about 9:50pm, moving in the direction of Corona and the Foster ranch. The problem with connecting the incidents is that Brazel stated in the *Roswell Daily Record* that he found

Splendor's Law
Analog, 2000
Pen & ink on scratchboard, fountain pen on legal paper
11in x 8in (28cm x 20cm)

'Splendor's Law' is a sequel to an earlier Dave Creek story, 'A Touch of Splendor' (Splendor being the name of a distant planet). Since I had illustrated the earlier instalment I made a point of repeating the little crescent-headed alien to help readers make the connection between the two, but I also tried to show the critter from an entirely different angle. The tricky part of this assignment was not coming up with outlandish-looking extraterrestrials but making sure the human female looked Asian. A slight variance in line could make all the difference in such a small drawing. The original image was drawn smaller than reproduction size to fit the art department's flatbed scanner.

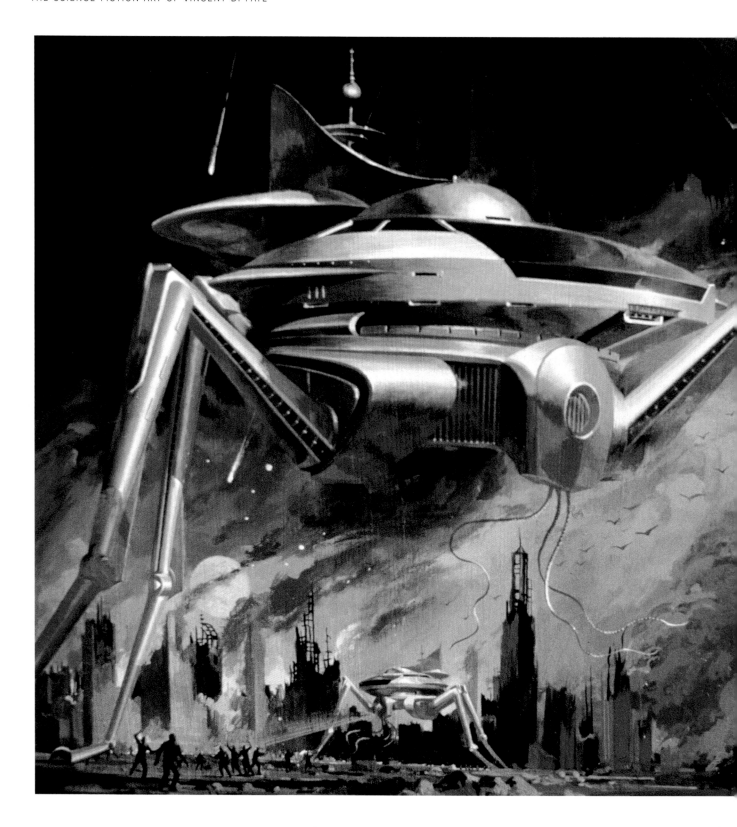

the debris on June 14, two weeks before the Wilmot sighting.

Moore and Berlitz, attempting to connect another seemingly related event, suggested that the object was struck by lightning near Corona, causing part of it to break away. Severely damaged, it scattered debris over the field where

Brazel found it sometime between July 3 and his meeting with Hollis Wilson on July 5. The injured object continued in a southwesterly direction until crashing to earth at the foot of the San Mateo Mountains, 150 miles (250km) southwest of Corona, near Soccorro.

There, according to Moore/Berlitz, and

dead bodies of the saucer's ostensibly non-human crew, the group was confronted by an Army officer in a Jeep who ordered them out of the area and warned them not to discuss what they'd seen. The addition to the story of a large, recognizable portion of a crashed saucer and the bodies of alien crew members would be embellished by later authors.

Barnett's account survives mainly through recollections by Vera and Jean Maltais of what he told them years later. Barnett, a reliable witness by reasonable standards, was, however, nowhere near Soccorro for the month of July 1947, according to notations in his wife's diary. Even to look at it in the most favourable light, his account is sketchy with respect to the date of the incident and in details that, if known, could provide corroboration. For instance, none of the students from the field trip has ever been located.

In the late 1990s, after much renewed interest in the incident, the Air Force released a massive study of the subject that validated Jesse Marcel's claims of a cover-up. According to Charles B. Moore, who in 1947 was an engineer on a top secret NYU project for the government called Project Mogul, the debris was most likely that of an aluminium-foil radar target that had been attached to a cluster of high-altitude balloons. The purpose of the balloons was to ascertain the presence in the upper atmosphere of radiation from Soviet atomic tests. A plane flying over the Pacific had detected the first Russian test, but in the tense political situation the sanctity of sovereign airspace made it necessary to use other means of monitoring Soviet atomic-weapons development. Balloons that could skirt the edge of space were a viable alternative in an era predating earth-orbiting satellites and high-flying craft like Lockheed's U-2 spy-plane. Marcel's original samples had likely been substituted with pieces of a common weather balloon to conceal the means by which the USA was scrutinizing its Cold War adversary. Moore's description of the materials used for the radar targets included tinfoil laminated onto a brown parchment-like paper, strips of balsa wood, and tape, some of which had a pink-and-purple floral pattern.

Less credible was the Air Force's explanation for the reports of alien bodies, which the study suggests were probably test dummies dropped from high altitude onto the desert

The War of the Worlds
Pocket, c1983
Acrylics on hardboard
Approx. 16in x 13in (41cm x 33cm)

Great stories are fun to revisit, particularly when they are open to a reinterpretation. I gladly gave *The War of the Worlds* a second try some four or five years later when Pocket Books commissioned me to do a cover for a new mass-market paperback edition. Wells had been very specific and detailed in his description of the war machines, noting, for instance, that their legs had a single joint and that the joint moved in only one dimension. The actual articulation of the tripod legs, however, is still open to interesting possibilities. Most artists have chosen to represent the motion of the machines as shambling and stiff-legged, but I wondered if structuring the legs like those of a crab or spider might not allow a more graceful and fluid kind of movement. I was happy with the results – a rarity for me – but, by the time I handed in the job, Pocket Books was having difficulties with the Wells estate, and this edition never made it into print.

based on the account of a civil engineer named Grady 'Barney' Barnett, the wreckage was discovered on the morning of July 3 by Barnett and a group of archaeology students from the University of Pennsylvania who were in the area on a field trip. While looking at the wreckage of what appeared to be a flying saucer, and at the

floor. Such tests, however, did not begin until the late 1950s.

In surveying all that embodies the reality and myth of Roswell, and despite the persistence of witnesses who have come forward over the years (to now number nearly 300), there is still little substantive evidence to support more than the most basic facts of the story. Jesse Marcel and 'Mac' Brazel (who died in 1963) can no longer provide information that isn't already on record. Walter Haut, who never actually saw the debris but believes it to have come from a downed craft of unusual type, can speak with certainty only about the press release and its subsequent retraction, and appears now to fully accept the Project Mogul explanation.

Accusations of a cover-up, partly now confirmed by the Air Force, are the True Believer's salvation. The extenuating issue of public access to government documents and purported wreckage stored in remote, secured facilities (such as the infamous Area 51) is one that offers a rationale for the absence of hard physical evidence. Exacerbating the situation is the Air Force's own admitted lack of candour, justified though that may have been. In many of its key aspects, the Roswell incident is a conspiracy theorist's dream come true, and discussion of it is likely to linger well into the 21st century.

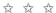

The Maury Island Mystery, on the other hand, was judged a blatant hoax almost from the start. It is best remembered today for two reasons: it was the first UFO case involving fatalities; and it introduced the term 'Men in Black' into the lexicon of flying-saucer lore.

It began with an incident that supposedly occurred on June 21, 1947 (three days prior to the Arnold sighting), on a prosaic island in Puget Sound near Des Moines, Washington. At 2:00pm on a calm but overcast day, Harold A. Dahl, two crewmen, Dahl's teenage son and his son's dog were on a boat in the sound just off Maury Island. Suddenly six doughnut-shaped vehicles came out of the clouds. They appeared to be metallic, and the perimeter of each was ringed by a row of large portals. One of the objects seemed to be experiencing difficulty, and its five companions formed a circle in the air above it. After a while, one of the ships descended and touched the injured ship. Materials from the damaged ship began falling from the opening at its centre to the water and the nearby beach. The rubble consisted of sheets of a light, aluminium-like metal and pieces of a black rocky substance that looked like slag. Dahl brought his boat in at Maury Island, grabbed his camera and ran along the beach taking pictures. While the hail of materials continued, Dahl's son sustained an injury to his arm and the debris struck and killed the boy's dog. Finally the six doughnut-shaped craft whisked off out to sea. When Dahl had the film developed, the pictures he took were spotted and cloudy, presumably because of radiation exposure from the strange vehicles.

Dahl reported the incident to Fred Lee Crisman, his boss, and a purportedly sceptical Crisman went out to Maury Island the following day. There he saw one of the mysterious ships for himself and discovered some 20 tons of debris littered about the beach. He took a sample of the slag-like material and sent it off to *Amazing Stories* editor Raymond A. Palmer in Chicago in early July; because of his editorials and the publication of the 'Shaver Mystery' in *Amazing Stories* (an allegedly true story about ancient aliens living inside the Earth), Palmer's interest in UFOs was well known, even in the earliest days of the flying-saucer craze.

While Crisman was at Maury Island on the morning of June 22, Dahl was at breakfast being interrogated and threatened by several men dressed in black suits who arrived at his door in a brand new black Buick sedan. Dahl was warned not to speak of the UFO incident.

Palmer, on receiving the sample and believing there might be something to the story, commissioned the now celebrated Kenneth Arnold and a United Airlines pilot named Captain E.A. Smith to fly to Tacoma to interview Dahl and Crisman. Arnold and Smith met with Dahl and Crisman twice during the closing days of July. They also looked at samples of the materials purportedly jettisoned by the injured craft, though Dahl and Crisman, who'd falsely represented themselves as harbour patrolmen, could not produce the spotted photographs that Dahl said he'd taken. Believing nonetheless that they might be onto something, on July 31 Smith phoned Lieutenant Frank Brown, an intelligence officer at Hamilton Air Force Base, California, and asked for assistance. Later that day, Lieutenant Brown and a Captain Davidson, also in intelligence, arrived at McChord Air Force

Hostile Takeover

Analog, 2001
Pen & ink on scratchboard
10.5in x 8in (27cm x 20cm)

This was for a story by Edward M. Lerner. I always welcome the opportunity to draw aliens, even if they are essentially humanoid. I have a strong suspicion that the homunculi populating so much fantastic fiction – and UFO-abduction accounts – are some sort of Jungian icon that comes pre-programmed into the human hard drive at that great factory in the heavens where we are assembled before delivery to planet Earth.

Base near Tacoma in a B-25. The intelligence officers interviewed Dahl and Crisman and quickly concluded that the men were attempting a hoax. They met briefly with their counterpart in the intelligence office at McChord before boarding the B-25 early in the morning of August 1 for the return trip to California. En route, the B-25 crashed near Kelso, Washington. The crew chief and another passenger parachuted to safety, but Brown and Davidson perished.

Subsequently several newspapers ran sensational accounts of the tragedy and of the alleged incidents of June 21 and 22 at Maury Island. The journalists inferred that the crash was the result of sabotage and that Brown and Davidson died because they knew too much, and claimed the two intelligence agents were carrying secret documents with information that the saucer-men wanted to suppress. One publication attributed the downing of the B-25 to an attack by a flying saucer that ruthlessly shot the plane out of the sky. Some of these details and those in earlier newspaper reports were leaked to the papers by anonymous phone calls – calls eventually traced to Dahl and Crisman. After a thorough examination of the wreckage at Kelso, investigators attributed the B-25 crash to a clogged exhaust pipe on the left wing that caused the wing to catch fire and break away, shearing off the tail of the plane. The secret files on board bore no relation to the Maury Island affair or UFOs. After the tragedy and the disclosure by the McChord intelligence officer that Brown and Davidson intended to file a report to the effect that the Maury Island sighting was a hoax, Dahl and Crisman confessed. They admitted that the affair had started out as a prank to exploit the gullibility of Ray Palmer and to get him to buy their story.

The Men in Black, however, would become fixtures in many subsequent UFO cases. Often portrayed as agents of some secret, covert organization within the government, through the years they've been conveniently able to abscond with or destroy evidence and to suppress eyewitness testimony. In some instances these elusive individuals are portrayed as minions of the saucer people – rogue humans in league with the aliens or alien/human hybrids, able to pass among us where they can keep the lid clamped on the sinister truth about flying saucers.

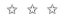

The Maury Island Mystery may have started out as an ill-conceived practical joke, but there was little humour in the events leading up to and including the next and most famous of all UFO-related fatalities, the death of Air National Guard pilot Captain Thomas F. Mantell. The Mantell incident occurred in January 1948, a scant four months after the newly formed US Air Force implemented its Project Sign, its 'secret' effort to track and investigate UFO reports.

US Army Chief of Staff Lieutenant-General Nathan Twining put the wheels in motion that led to the formation of Project Sign in September 1947. That effort was established under the auspices of the Air Technical Intelligence Center at Wright-Patterson Air Force Base in Dayton, Ohio. It was an earnest undertaking, but a modest one, meant not so much to provide a scientific assessment of UFOs as to reassure a Cold War-weary military that the 'unknowns' were being vigilantly evaluated as to source and intent. Scientists in specialized fields were employed as consultants as the need arose; and the investigation of the Mantell incident was the first to engage the services of Dr J. Allen Hynek. Hynek, an astrophysicist and a professor of astronomy at Ohio State University, would become the chief scientific investigator for the Air Force until the UFO project, twice forsaken and reorganized under different names, was abandoned in 1969. He would be the source of the controversial 'swamp gas' explanation for the 1966 UFO sightings in Ann Arbor, Michigan.

Events leading to Mantell's death first came to the attention of military authorities shortly after 1:15pm on January 7, when the Kentucky State Highway Patrol phoned the control tower at Godman AFB to ask if the base had any information about a UFO reported in the area. About half an hour later, air-control personnel at Godman were able to see the object through the windows of the tower. The UFO was first

The Blackcollar
DAW, 1983
Acrylics on hardboard
Approx. 13.5in x 23in (34cm x 58cm)

Timothy Zahn's *The Blackcollar* tells of an elite fighting force of human warriors, chemically enhanced and scrupulously trained to wage hand-to-hand combat with the invading Ryqril. The presence of extraterrestrial invaders gave me an opportunity to paint aliens (an event that, by the early 1980s, was becoming all too rare as my reputation as a 'gadget' painter took hold), and the sheer bravura of the story allowed me to pay homage to the pulps I so dearly loved when I was growing up.

observed over Maysville, then at Owensboro and Irvington, travelling in a westerly direction. The object was very bright and of tremendous size, with estimates placing it at 250–300ft (75–90m) in diameter. While most witnesses thought it was circular, one observer at Godman tower described it as looking like an ice-cream cone with a red light at one end. Later witnesses, one with a telescope, another with binoculars, identified it as a balloon.

At about 2:30pm a flight of four F-51D Mustangs from the Air National Guard's 165th Fighter Squadron entered the area and were enlisted in the search. The Mustangs left Marietta AFB, Georgia, on a low-altitude training mission with a destination of Standiford AFB, Kentucky. Because of the limited nature of the mission, the planes were not outfitted with oxygen. Piloting the four planes were flight leader Captain Mantell, 1st Lieutenant R.K. Henricks, 1st Lieutenant A.W. Clements and 2nd Lieutenant B.A. Hammond. Henricks, who was low on fuel, was granted permission to continue on to Standiford. Mantell aggressively took the lead as soon as coordinates of the object's location were radioed from Godman tower.

At 3:15pm, wingmen Clements and Hammond, nearing an altitude of 20,000ft (6100m), broke off the climb due to the lack of oxygen. Mantell proceeded, saying he would continue his pursuit for another 5000ft

(1500m) and would cease after ten minutes. By this time Mantell had been in sight of the UFO for nearly half an hour. His excited description of the object was that it was 'metallic and of tremendous size'.

At about 25,000ft (7600m) he blacked out. His plane levelled off, then fell into a high-speed dive, spiralling towards the earth. When he regained consciousness he attempted to pull up, but the stress forces caused his plane to break apart. It slammed into the ground on a farm near Franklin, Kentucky. Examination of the wreckage found Mantell's body in the cockpit with the hands of his wristwatch stopped at 3:18pm. His blackout, recovery and descent occurred all in a matter of a few minutes.

In the meantime, Clements, unaware of Mantell's fate, radioed in that the object looked 'like the reflection of sunlight on an airplane canopy'. At 3:50pm observers at Godman tower lost sight of the object, though reports continued to come in from communities to the south and west of the airfield until about 5:00pm. Clements refuelled his plane at Standiford and, after being outfitted with oxygen, returned to the search but was unable to locate the UFO.

The official pronouncement was that Mantell's death had been caused by the pilot's futile pursuit of an atmospherically distorted image of the planet Venus, and in the excitement of the chase he simply ran out of air and blacked out. On January 7 Venus was indeed situated at about where the UFO had been sighted but, contrary to the official statement, Hynek and others at Project Sign were well aware that the planet was too faint at the time to have been visible against the bright afternoon sky. Lieutenant Clements's radio description prompted authorities to consider the possibility that a reflection off the canopy of Mantell's own plane might have been the source of the UFO. That, however, would not explain the widespread sightings by ground observers, nor would it square with the fact that Mantell had it in view for nearly 30 minutes. Unofficially, the personnel at ATIC were all but certain that Mantell was killed chasing a spaceship from another world.

In 1952 Captain Edward Ruppelt, the newly appointed head of the Air Force's UFO project (by then renamed Project Bluebook), reopened the investigation and concluded, with the help of Hynek, that Mantell crashed while pursuing a

Skyhook balloon. Supporting this explanation was the fact that just such a balloon had been launched from Camp Ripley, Minnesota, in the early hours of January 7, and that prevailing winds in the upper atmosphere would have likely carried it in a southerly direction towards Kentucky and Tennessee; Skyhook balloons were also launched on or about the 7th from Clinton County AFB, Ohio. The Skyhook possibility had in fact been raised three years earlier by Sidney Shalett in the April 30, 1949, issue of the *Saturday Evening Post*; but, notwithstanding its public attitude on the subject of UFOs, the pro-saucer tunnel vision of authorities at ATIC at the time had simply led them to ignore the balloon explanation. In *Scientific Study of Unidentified Flying Objects*, the controversial 1969 University of Colorado report commissioned by the Air Force, Dr Edward U. Condon, the project's director, ended his summary of the Mantell incident with this statement concerning the Skyhook balloon explanation: '. . . though plausible [this] is not a certain identification.'

It was apparently not a balloon, or anything like it, that closed on a collision course with Eastern Airlines flight #576 six months later, in the small hours of the morning of July 24, 1948. Pilot Clarence S. Chiles and co-pilot John B. Whitted were confident in their descriptions of a wingless, cylindrical object some 100ft (30m) long and 25–30ft (7.5–9m) in diameter with a double row of brightly lit windows along its side. The UFO, first appearing as a red light in the distance, swept down out of a clear, moonlit sky at 2:45am, approaching the DC-3 as it cruised at an altitude of 5000ft (1500m) just to the southwest of Montgomery, Alabama. The object trailed an exhaust of bright orange-red flame 50ft (15m) long as it veered sharply to the right in an apparent attempt to avoid colliding with the airliner. A passenger who had happened to be looking out the window corroborated the presence of the object as it shot past, describing it as an eerie streak of light of very bright intensity. The flight, which originated from Houston, Texas, was heading northeast to Atlanta, Georgia, when it had its brief encounter with the unknown.

In all, the object was in view of the pilots at close range for a little more than ten seconds, and both were able to provide comprehensive

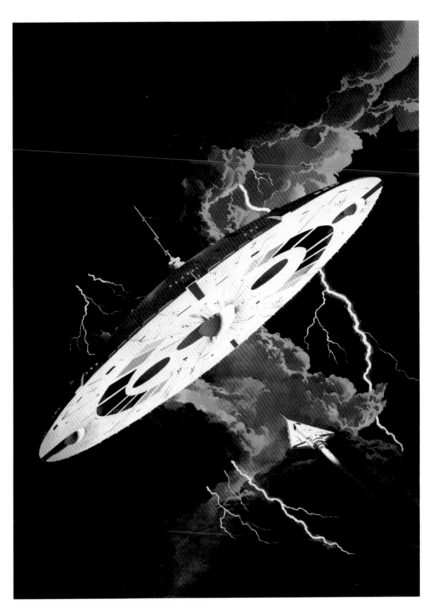

descriptions that differed only slightly in detail. Chiles thought the craft had a boom at the nose, and an illuminated cockpit tapered toward the back, where the exhaust flames were expelled from a nozzle. He also thought the central section of the fuselage was transparent, and that it had a dark, bluish glow to its underbelly. Whitted had no recollection of the boom, the lighted cockpit or the exhaust nozzle, but did recall the windows, the blue glow to the object's underside and the tail of bright flame. Both agreed that it looked like a B-29 without wings. Bolstering the Chiles-Whitted report was a pilot sighting of a bright shooting star at about the same time near the Virginia/North Carolina border. A few minutes later another sighting was made over Robins AFB in Macon, Georgia.

Although no explanation has ever really stuck for the Chiles-Whitted encounter, Hynek

A World in the Clouds

Analog, 1980
Acrylics on hardboard
Approx. 14in x 18in (36cm x 41cm)

This painting was originally created for a Bob Buckley story in *Analog*, but it has since been widely reproduced in conjunction with articles about UFOs – the vessel's distinctive disc-like appearance being the obvious reason. In the original story it was supposed to be a survey station designed for use in the volatile atmosphere of Venus. This was the first of two instances in which I used this particular, highly dramatic sky. I recycled it again a little while later to stand in for the atmosphere of Jupiter in the painting *Galileo Probe* (see page 61).

Odysseus

Analog, c1994
Pen & ink on scratchboard
7in x 11in (18cm x 28cm)

Done for a story of this title
by John G. Hemry. The con-
cept of derelict ships encoun-
tered in the frozen depths of
space is a long-standing and
highly appealing theme in
science fiction literature.

believed the object was a very bright meteor.
Both pilots, as well as the authorities at ATIC,
rebutted this on the basis that the UFO
appeared to be under intelligent control and
that it rose upward in a steep climb after veering
from its near collision with the DC-3. Amateur
astronomers throughout the region, however,
reported seeing numerous bright meteors on the
evenings of July 24 and 25.

☆ ☆ ☆

Whatever Chiles and Whitted saw, whatever
lured Mantell to his death or danced above the
peaks of Mount Rainier to Kenneth Arnold's
amazement, the staff of Project Sign was nearly
convinced by late July 1948 that *They* had
arrived, under their own power and by their
own effort of will, from the depths of outer
space. What underscored the likelihood of the
extraterrestrial hypothesis for many at ATIC was
the fact that no known earthly metals could
withstand the rigours brought on by the
extreme high speeds and manoeuvrability
reported in UFO sightings. Nor could any
human survive the G-forces exerted by those
manoeuvers. Nearly four years would pass
before Ruppelt endorsed the Skyhook-balloon
explanation of Mantell's death, offering the first
plausible alternative to the extraterrestrial
hypothesis in that case. Meanwhile the Chiles-
Whitted sighting, with the testimony of two
highly skilled and experienced commercial
pilots and the corroboration of three credible
independent witnesses, was especially convinc-
ing to those within the military establishment.

At the end of July 1948 the Air Force's

Technical Intelligence Division, along with
Project Sign, submitted a formal top-secret
'Estimate of the Situation' to Air Force Chief of
Staff General Hoyt S. Vandenberg. The report
concluded that UFOs were vehicles of inter-
planetary origin. Vandenberg rejected the report
on the grounds that it failed adequately to sup-
port its own conclusion, and ordered all copies
destroyed, although rumour has it some sur-
vived. Ruppelt stated in *The Report on
Unidentified Flying Objects* that a contraband
copy was offered to him for his perusal, but that
circumstances prevented him from accepting.
Like its mercurial subject, the 'Estimate'
remains elusive and forever unavailable for clos-
er scrutiny.

In the weeks and months to follow there
would be more startling rendezvous with the
unknown. Sixty-eight days after the Chiles-
Whitted sighting another Air National Guard
pilot, Lieutenant George F. Gorman, engaged
his F-51 in a dogfight with a UFO – including
another near head-on collision – in the night-
time skies over Fargo, North Dakota. The object
was later identified as a balloon.

During the following month, November 1948,
mysterious bright green fireballs were seen over
Albuquerque, New Mexico. Because the
Albuquerque/Los Alamos area is militarily sensi-
tive (it's where nuclear weapons are developed,
tested and stored), it was essential to determine
the nature of these objects as quickly as possi-
ble. Scientists from the Los Alamos area were
summoned to offer their expertise; among them
was Dr Lincoln La Paz. La Paz, an international-
ly revered scientist, was Director of the Institute
of Meteoritics at the University of New Mexico,
and the world's foremost authority on meteorites;
he was also the first creditable scientist connected
to the Air Force's UFO investigation to express
publicly the view that in some instances, and
almost certainly in the case of the green fireballs,
UFOs could not be explained away as natural phe-
nomena. Although most of the other consultants
on the case believed these were meteors, no fully
satisfactory explanation for the sightings has
ever been made. Those green fireballs, which
continued to be seen through January 1949,
prompted the creation, later that summer, of
Project Twinkle, an elaborate undertaking by the
Air Force's Cambridge Research Laboratory to
study and photograph the fireballs. By then,
alas, the wave of sightings had all but ended.

☆ ☆ ☆

In February 1949 Project Sign's name was changed to Project Grudge, the rationale being that the original codename had been compromised. From the very start it had been impossible to keep the existence of Project Sign a secret. As UFO witnesses across the country were interviewed by the press, reporters would discover that Air Force personnel had preceded them. Only the codename remained truly secure for most of the 16 months of Project Sign's existence; for lack of an alternative, the press had taken to calling it Project Saucer. In a way, knowledge that the military was actively keeping tabs on UFOs was tremendously reassuring to the public, and so the Air Force took its time in making the change.

Along with the eventual change in name came an unofficial change in attitude, however. For the next three years, and despite the growing number of quality cases that came to its attention, Project Grudge was intent on debunking UFOs.

Project Bluebook supplanted Grudge in March 1952. Largely on the strength of the trustworthiness of its chief, Edward Ruppelt, the new investigation took on an aura of greater impartiality. At least two Bluebook 'alumni', Ruppelt and Albert M. Chop, the public relations officer for the Air Force's Air Materiel Command, were transformed by their experience on the project and were, if not True Believers, at least open-minded on the subject of UFOs. So, too, eventually, was J. Allen Hynek in the years following Project Bluebook's termination.

☆ ☆ ☆

Against the backdrop of Cold War anxiety around the world, social and political unrest at home and growing unease among America's youth, fantastic headlines about UFOs continued to appear well into the 1960s, giving birth to the glorious Technicolor visions of American science-fiction cinema. In another backwater area of popular culture, the novelty song market, Luniverse Records released *The Flying Saucer* and *Santa and the Satellite* in 1957 and 1958; although these became instant hits, both were banned from the airwaves for fear they would cause the kind of mass panic that accompanied Orson Welles's infamous 1938 radio broadcast of *The War of the Worlds*. The Air Force's UFO files were full of references to that Mercury Theatre broadcast and its aftermath, and, in the absence of anything more concrete, it became the sole barometer for gauging the public's response to an extraterrestrial visitation.

There were also out-of-this-world fashions, a variety of otherworldly foods and toys, and a spate of far-out shows intended to transport the viewer to the edge of space and beyond through the questionable magic of live television. Among the new and exotic foods being served were the Carvel 'Flying Saucer' (a sandwich of soft-ice cream between two hard circular chocolate cookies), a variety of Saucerburgers and Atomic Flying Saucer fountain drinks. Although many UFO-related toys have come and gone, the one that has somehow eluded extinction is the ubiquitous frisbee, a fixture of virtually every beach and lawn party since its introduction in the 1950s.

☆ ☆ ☆

And thus, for a brief period in the mid-20th century, it was acceptable to believe in the unbelievable. I began this essay by stating that I didn't believe in flying saucers, but in truth it hardly matters to me what they are, or even *if* they are. The fact that there was such a time of widespread belief is all that really matters; the reality is only of secondary concern. I've long felt that the larger part of the UFO mystery lies within the human psyche. This is not to say that we imagined it all, but rather that much of what we perceive in the outside world originates within us. If we are indeed being scrutinized by intelligences unknown to us, they must come from a realm in which time and space are irrelevant, for the vast distances and the time it takes to traverse them are the ultimate enemies of a rational belief in alien tourists. In the beginning, when these phenomena were new to us, it was a fearsome yet strangely glorious and exciting time to be alive. In the end, when the mystery is finally known, I think we'll learn that *we* were the aliens all along – that there was nothing to fear but our own ignorance of ourselves, our potentials and our reasons for being.

I remember that beginning, some half-century ago, as vividly as if it were yesterday. And I think of it fondly. It was a time when flying saucers were from outer space and Little Green Man from Mars *did* exist – if nowhere else than in the heart and mind of a seven-year-old who once believed that anything was possible.

The Company Man

Analog, 2001
Pen & ink on scratchboard
Approx. 12in x 7in (30cm x 18cm)
8.5in x 11in (22cm x 28cm)

'The Company Man' is a short story by Daniel Hatch
with all the elements any self-respecting sf fan would
love – and any sf illustrator would love to draw. I
seldom save the preliminary sketches from my black-
and-white assignments, and usually refuse to show
them to my clients in advance of the finish because
I feel this kind of art lends itself to spontaneous
alteration. If a better idea strikes me in the final
stages of the drawing, I like to have the flexibility to
move in a different direction.

FACING PAGE
Mission of Gravity

Easton Press, 1987
Pen & ink on scratchboard
Approx. 7in x 10in (18cm x 25cm)

Hal Clement's *Mission of Gravity* is widely regarded as
one of the greatest hard-sf novels. A probe from Earth
crash-lands at the pole of the oddly shaped planet of
Mesklin, where the force of gravity varies radically
from one location to another; at the crash site it is
several hundred times that of Earth's. To retrieve the
device, the Earth scientists must enlist the aid of the
locals, the Mesklinites, a strange, caterpillar-like race
of creatures with a pronounced fear of heights. That
fear is put to the test in this scene as the Mesklinites
approach the edge of a sheer cliff with their tank,
the *Bree*.

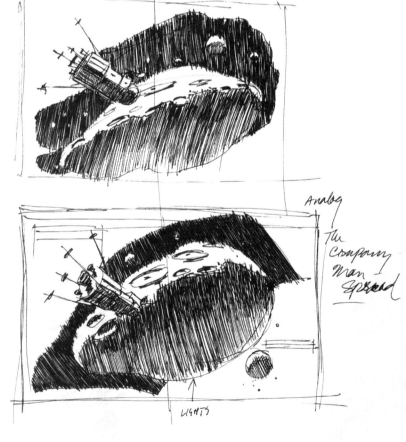

FUTURE IMAGINED

ALMOST ALL of the over 3000 published works I've produced over the past three decades have been drawings and paintings of things that don't exist. Without that freedom to invent, much of the illustrator's job is reduced to the tedium of representing the world in the prosaic terms of everyday life. I could not have lived that kind of banal existence, for I am both blessed and cursed by a short attention span and a fierce desire to see what lies just beyond the horizon.

The illustrator of the fantastic takes elements of the known world and integrates them with things derived wholly from the imagination. The craft involved in this process lies in hiding the seams between what is real and what is imagined, so as to produce a convincing vision that defies the viewer's inclination towards disbelief. I hope I've been at least competent at it.

I feel truly fortunate to have been given a sense of imagination and the ability to make my living by it. When I think of all the aspirations I had as a younger man that remain unrealized, I still cannot conceive of how any other path I might have taken would have been so fruitful. What you see here is a personal journey of the imagination to far worlds and distant lands, to the deep, unfathomable voids that lie between the stars, and to the wonders of our own time and the great achievements of our species. For all that's here, this marks only the beginning – not only for me, but for the rest of us.

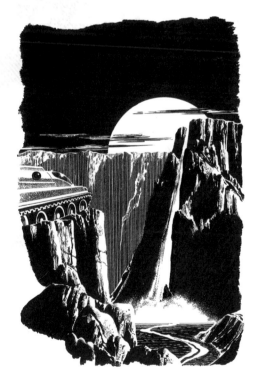

Tomorrow will be wondrous and exquisite beyond what we can now conceive. It lies out there awaiting us, if only we have the wisdom to dream it and the desire to make it so.

ABOVE
Timemaster
Tor, 1992
Acrylics on hardboard
15in x 16in (38cm x 41cm)

Robert L. Forward's novel *Timemaster* includes a description
of a spaceship that looks suspiciously like a garbage can. At
the time I got the assignment the book had not been fully
written; with no manuscript available, I relied more than
usual on the input of the book's editor. As you might
imagine, pictures of spaceships that resemble garbage cans
can be offputting, and I soon found myself in the middle of
a feud between the publisher and the editor. The final result
was what you see here – a far more conventional vision of
the near future, with sleek space-planes soaring about a
traditional torus-shaped space station.

BELOW AND RIGHT
The World of Null-A
Easton Press, 1988
Painting
Acrylics on hardboard
Approx. 14in x 22in (36cm x 56cm)
Drawing
Pen & ink on scratchboard
Approx. 8.5in x 2.5in (22cm x 6cm)

A.E. van Vogt's Null-A stories are enduring classics, and I've
had the pleasure of illustrating all three of them at least
twice. This time around it was for a special Easton Press
leatherbound edition, for which the little drawing below
was a running chapter heading. Protagonist Gilbert Gosseyn
is a superman with a troubling secret than not even he fully
understands. This novel has everything – action, adventure,
intergalactic conspiracy, alien invasion and colossal confu-
sion. And it's only the first in the series!

RIGHT
The Billion Dollar Boy
Tor, 1996
Acrylics on hardboard
Approx. 14.25in x 24in (36cm x 61cm)

Space rescues are inherently dramatic and attractive to most sf
fans, but this scene represented merely one short stop along the
way to the Messina Dust Cloud in a heart-pounding adventure
yarn by Charles Sheffield. This was a novel in the *Jupiter* series, a
special line of books aimed at younger readers.

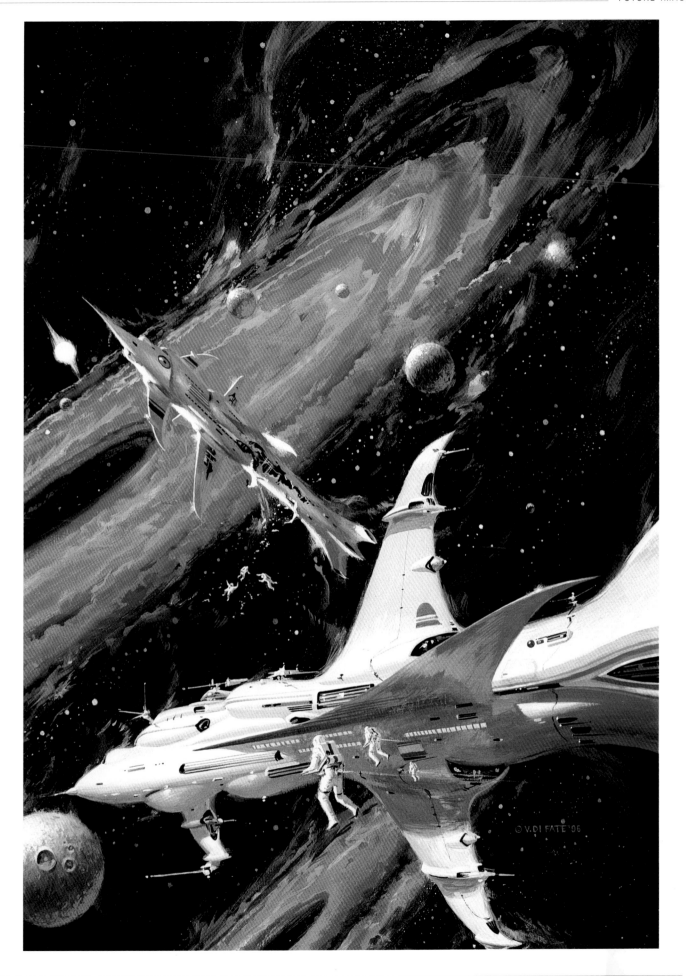

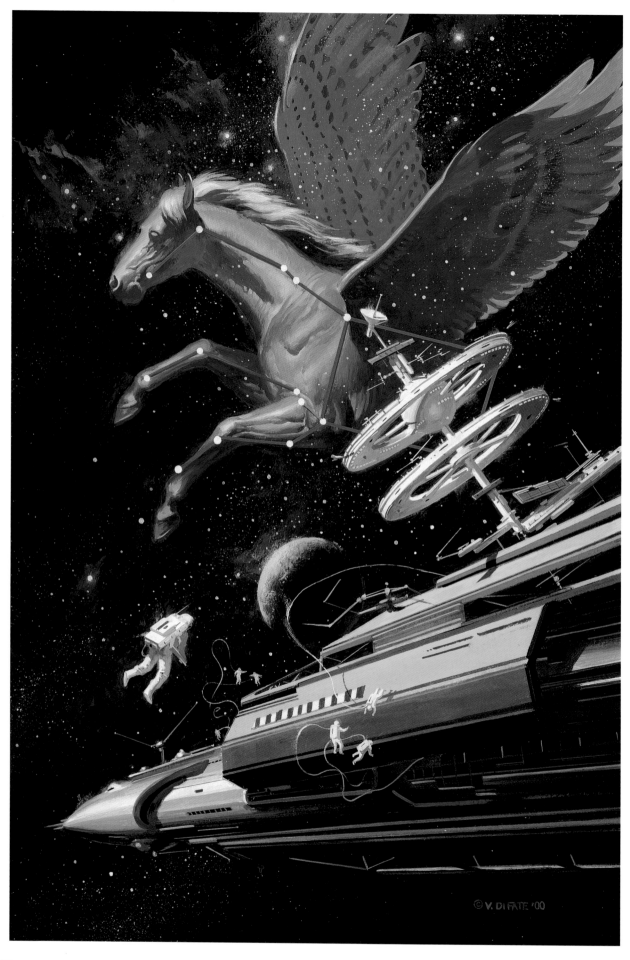

RIGHT
The Century Next Door
Science Fiction Book Club, 2000
14.25in x 19in (36cm x 48cm)

This was for the cover of a collection of linked stories by John Barnes, an emerging superstar in the sf field. The particular storyline involved a generation ship hollowed out of an ancient asteroid and its less than triumphant return to Mother Earth.

BELOW
The Century Next Door
Sketch
Acrylics on hardboard
5.5in x 8.5in (14cm x 22cm)

The sketch is always the perfect vehicle for experimentation.

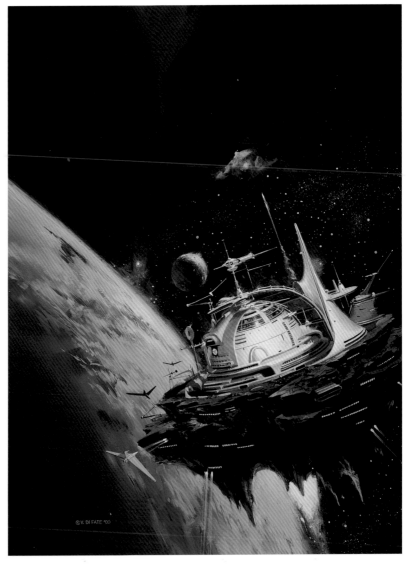

RIGHT
Rules of Engagement
Easton Press, 1999
Acrylics on hardboard
11.75in x 16.5in (30cm x 42cm)

The opportunity to paint pretty girls is a rare event in the life of a 'gadget' artist like me, so I was very happy to work on this assignment for an Elizabeth Moon novel when it came along. The girl was supposed to be gorgeous in a tomboyish sort of way – quite a challenge for someone who is at best only an infrequent visitor to this kind of subject matter.

LEFT
Pegasus in Space
Easton Press, 2000
Acrylics on Acryla-Weave
10.25in x 15in (26cm x 38cm)

I've long admired the writings of Anne McCaffrey, ever since encountering the first of the *Pern* stories when they ran in *Analog* back in the 1960s. Although the *Pegasus* series is unrelated to those, I was truly delighted to work on this special edition. As it turned out, Ms McCaffrey had been appalled by a recent painting for one of her books (thankfully, *not* one of mine!) and had negotiated art approval with the folks at the Easton Press. This gave me an opportunity to communicate with her via e-mail in one of the most pleasant and cordial exchanges I've ever had with an author. The manuscript was still being revised while I was working on the painting, so I got to see a part of this great novel take shape before my eyes.

Mission to Other-Earth

1979–80
Acrylics on hardboard
Approx. 12in x 16in (30cm x 41cm)

This image was created, in part, in 1979 as an assignment for the National Geographic Society. Not entirely satisfied with the final results, I altered the painting after it was initially published to include the spaceship and the limb of the twin Earth in the foreground. At the time I was intrigued by the concept of parallel worlds and multi-dimensional realities. The altered painting first appeared in *Di Fate's Catalog of Science Fiction Hardware* (Workman, 1980), then on the cover of *The Psychotechnic League*, a collection of landmark sf stories by Poul Anderson (Tor, 1981).

FACING PAGE
Star Swarm

Tor, 1997
Acrylics on hardboard
Approx. 16in x 24in (41cm x 61cm)

The novel for which this art was created was originally written by Jerry Pournelle for inclusion in the *Jupiter* series (see page 20), but in the end was released by itself. This is a scene right from the manuscript with one notable exception – the monstrous sea creature is described as black.

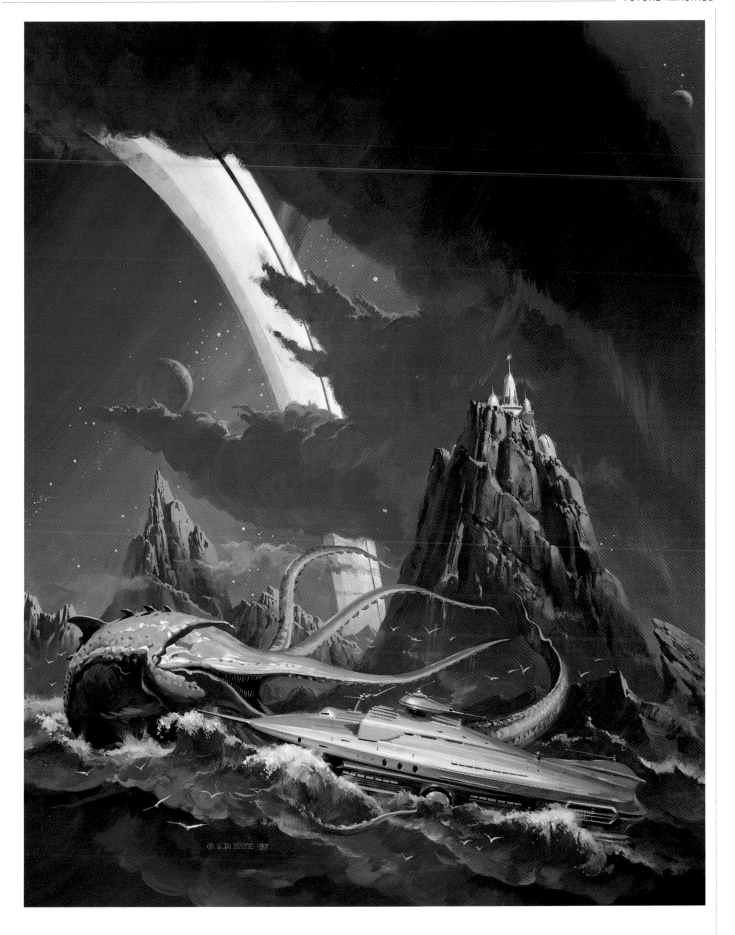

© V. Di FATE '97

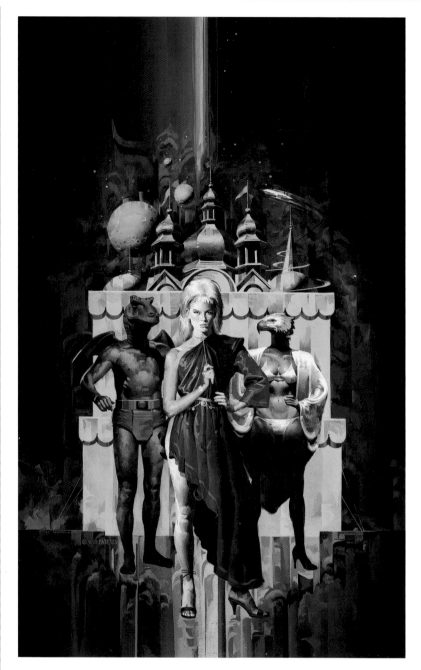

ABOVE
Melome
Sketch, 1983
Acrylics on hardboard
6in x 10in (15cm x 25cm)

Convincing the client that I could pull off a painting of a pretty girl after having been branded a 'gadget' painter for more than a decade was no mean feat. The challenges of the assignment compelled me to do a far more comprehensive sketch than customary for me at the time, and thereby I learned an important lesson: the sketch is everything. If it doesn't work there, it won't in the finish, and, more importantly, if the sketch succeeds, there's no rational reason why the finish shouldn't too.

LEFT
Melome
DAW, 1983
Acrylics on hardboard
14.25in x 23in (36cm x 58cm)

This was a book in the *Dumarest of Terra* series, a cycle of adventure stories by E.C. Tubb concerning a spacefarer who, like Odysseus, is lost during his quest to return home. In this particular adventure Dumarest encounters Melome, an ingénue with psychic powers who is a performer in a travelling interplanetary circus. The assignment afforded me an opportunity to paint a pretty girl, something I'm all too seldom asked to do.

RIGHT
Solstice
Amazing Stories, 1986
Acrylics on hardboard
Approx. 14in x 19in (36cm x 48cm)

Done for the cover of the July 1986 issue of *Amazing Stories*, this illustrates a story by Bill Johnson about a mission to Mars. It was designed to work with the magazine's comet-tail logo, a feature that disappeared with the end of the pulp era but was finally reinstated. For us older fans the reversion to that nostalgic style was like being reunited with a long-lost friend.

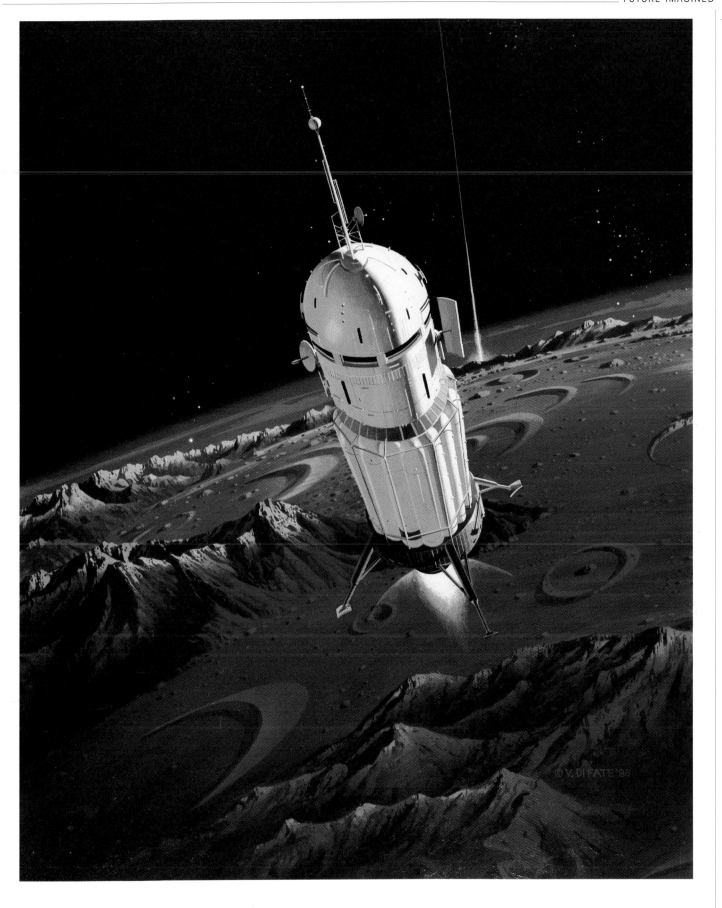

INDEX OF WORKS

Penterra

Worldwide Library, 1988
Acrylics on hardboard
14in x 21.5in (36cm x 55cm)

This was the cover painting for a novel by Judith Moffett. I may not be a virtuoso of composition (that critical part of picture-making that involves the combination and placement of objects), but I seldom mishandle it – that is, unless I'm specifically asked to do so. As an illustrator I'm well aware that a part of my job is to give the client what he or she asks for. In this case the art director specifically requested that I split the picture in two, with one side showing the ravages of industry and the other showing a Utopian paradise. More puzzling to me even than being asked to do such a thing is that, somehow, it seems to work here.

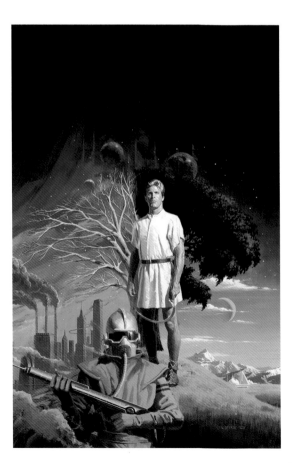